Donna Dewberry's
Essential
One-Stroke
PAINTING REFERENCE

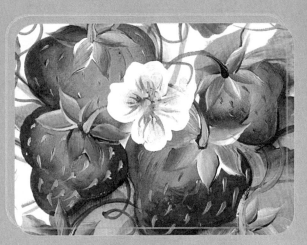
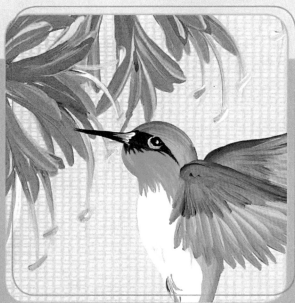
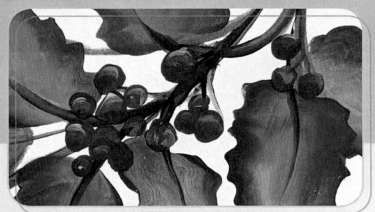

Donna Dewberry's
Essential
One-Stroke
PAINTING REFERENCE

NORTH LIGHT BOOKS
CINCINNATI, OHIO
www.mycraftivity.com

Donna Dewberry's Essential One-Stroke Painting Reference.
Copyright © 2009 by Donna Dewberry. Manufactured in China. All rights reserved.
No part of this book may be reproduced in any form or by any electronic or mechanical
means including information storage and retrieval systems without permission in writing
from the publisher, except by a reviewer who may quote brief passages in a review. The
content of this book has been thoroughly reviewed for accuracy. However, the author and
publisher disclaim any liability for any damages, losses or injuries that may result from
the use or misuse of any product or information presented herein. It is the purchaser's
responsibility to read and follow all instructions and warnings on all product labels.
Published by North Light Books, an imprint of F+W Media, Inc., 4700 East Galbraith
Road, Cincinnati, Ohio, 45236. (800) 289-0963. First Edition.

 Other fine North Light Books are available from your local bookstore, art supply
store, online supplier or visit our website at www.fwmedia.com.

PB: 13 12 11 10 09 5 4 3 2 1
HB: 13 12 11 10 09 5 4 3 2 1

Distributed in Canada by Fraser Direct
100 Armstrong Avenue
Georgetown, ON, Canada L7G 5S4
Tel: (905) 877-4411

Distributed in the U.K. and Europe by David & Charles
Brunel House, Newton Abbot, Devon, TQ12 4PU, England
Tel: (+44) 1626 323200, Fax: (+44) 1626 323319
Email: postmaster@davidandcharles.co.uk

Distributed in Australia by Capricorn Link
P.O. Box 704, S. Windsor NSW, 2756 Australia
Tel: (02) 4577-3555

Library of Congress Cataloging-in-Publication Data

Dewberry, Donna S.
 Donna Dewberry's essential one-stroke painting reference /
Donna Dewberry.
 p. cm.
 Includes index.
 ISBN 978-1-60061-131-5 (pbk. : alk. paper)
 ISBN 978-1-60061-756-0 (hardcover : alk. paper)
 1. Acrylic painting--Technique. I. Title. II. Title: Essential
one-stroke painting reference.
 ND1535.D49 2009
 751.4'26--dc22
 2008043053

Edited by Kathy Kipp
Cover design by Clare Finney
Interior design and layout by Doug Mayfield
Production coordinated by Matthew Wagner
Photography by Christine Polomsky

METRIC CONVERSION CHART		
To convert	to	multiply by
Inches	Centimeters	2.54
Centimeters	Inches	0.4
Feet	Centimeters	30.5
Centimeters	Feet	0.03
Yards	Meters	0.9
Meters	Yards	1.1

ABOUT THE AUTHOR

Donna Dewberry is the most successful and well-known decorative painter ever. Since 1998, she has created ten full-size instructional books for North Light. She is a popular television presenter on the Home Shopping Network, and her new program, "The Donna Dewberry Show," can be seen weekly on PBS stations nationwide. Her one-stroke designs are licensed for home décor and quilt fabrics, wallpapers, borders, stencils. etc. Donna's most recent North Light books are *Fast & Fun Landscape Painting* (2007) and *Fabric Painting with Donna Dewberry* (2008).

DEDICATION

This book is dedicated to all the influential women in my life up to this point: my late mother, Doris; grandmother Alice; mother-in-law Roberta; grandmother-in-law Annabelle; my sister Kim; my daughters Maria (1977–2000), Kara, Amanda and Anna; and my daughters-in-law Lynn and Laurie. These women, some of whom are now gone from this life, have all played an instrumental part in who I am. Their influence on my life has been, and will continue to be, an important part of me. Many smiles as well as tears have been shared with these women past and present. I love each of them dearly and each one is unique in her own way. I can't imagine them not being part of my life. When all is said and done, the memories we have will be all we can take with us. Mine will be wonderful and precious to me.

— Donna

ACKNOWLEDGMENTS

The year 1995 brings many good memories to mind. This was the year I discovered that all my previous years of "decorative painting" (a term unknown to me at the time) had prepared me for a path I had never dreamed of. I attended a local decorative painting convention and discovered a whole new world of people just like me whose passion was painting. I saw incredible painting and found myself feeling a little envious. As I had the opportunity to meet with some of these painters, I found they were not only wonderful artists, but very kind and genuine in welcoming me and others to their industry. That evening spent among them changed the direction of what was to become my painting path for the next decade.

I would like to acknowledge all my fellow painters for their inspiration and example, which has provided the direction for much of my painting career. They were, and still are, some of the most creative and giving people I know. Thank you!

Table of Contents

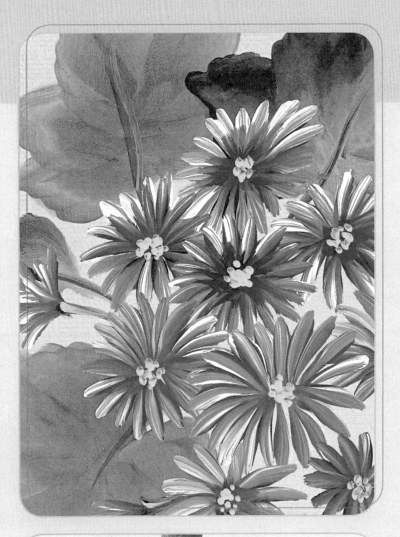

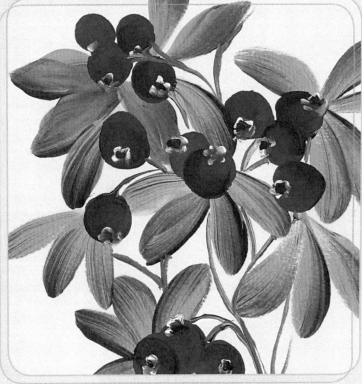

Donna's 10 Best Tips for One-Stroke Painting Success

When I first began to paint, I tried everything I could think of to get my paintings to look good! Slowly but surely, as I sat painting at my dining room table in the evenings after the children had been put to bed, I discovered that loading my brush with two colors at one time produced the look I wanted—blending, shading and highlighting all in one stroke. As the years have gone by, my skills have improved and I have learned how to teach others the One-Stroke method of painting. I've also seen that students tend to struggle with the same things no matter where I teach, so here are ten of my best tips to help you succeed at painting right from the start!

TIP 1: Don't skimp on paint when loading your brush. You need plenty of paint in the bristles so you don't run out mid-stroke. The brush should be loaded so the paint is at least two-thirds of the way up the bristles. When you are double loading your brush, keep picking up paint and blending on your palette until the bristles can hold no more paint. Repeat this process often as you are painting and your strokes will be smooth, well-shaped and beautifully blended.

TIP 2: Don't rely on patterns. Patterns force you to copy some-one else's look and style. Learn to paint freehand and your work will look fresh, spontaneous, and unique to you. When planning a design, take into consideration the shape of the surface and the natural growth of the chosen flower. If the surface is tall and slender then choose a flower that naturally grows tall and slender like a tulip or an iris. Another option is to paint a flower that grows on a climbing vine. These are much better choices than to paint a flower that grows close to the ground like an African violet.

TIP 3: If you make a mistake while you're painting, you can just paint over it as long as the paint underneath is still wet. Or cover it with a leaf or filler flowers. Most of the time you will be the only one who knows you made the mistake in the first place.

TIP 4: Spend time experimenting with color combinations and getting to know what you like best. You'll save time when you are trying to double load your brush with the right colors and your finished paintings will be harmonious and eye-catching. I always use white or yellow as the light color and then a darker color. I rarely use two colors that are closely related such as two reds. By using a light color and a dark color, you will automatically get all the shades in between.

TIP 5: If you are having trouble painting curlicues, here are a few things that will help. Always make sure you are using "inky" paint. The paint needs to be thinned in order for it to run down the bristles to the tip. Keep the handle straight, a slight tilt to the handle will cause the bristles to bend and make thick lines

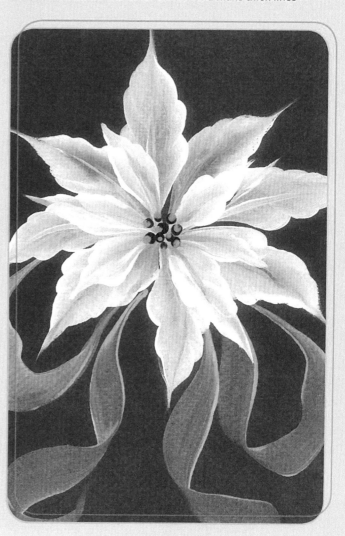

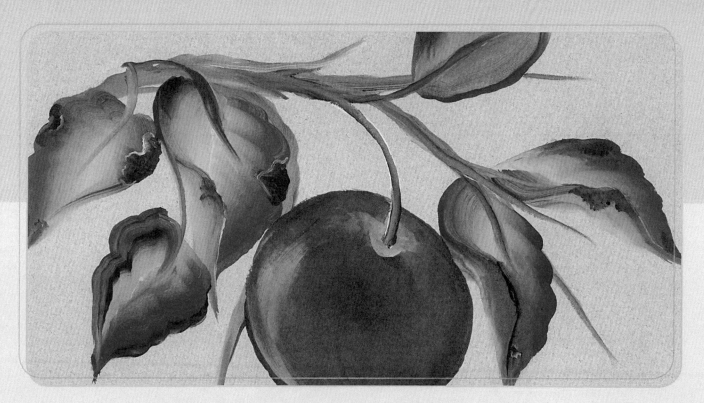

or sharp bends. Use only the tips of the bristles. If you can, brace your pinky finger on the surface to help steady your hand. If you can't extend your finger, then rest the arm of the painting hand lightly on top of the other forearm. Avoid using just finger or wrist movement—your whole arm needs to move to keep the brush the same distance away from the surface and keep the handle straight. If you use your wrist or fingers, you will cause the handle of the brush to tilt. Practice these tips and you will have the best curlicues imaginable.

TIP 6: To keep your brushes in good working condition, make sure you clean them thoroughly. If you don't have time to clean them properly, leave them in water until you can clean them later. Make sure to use the side of the water container that has the brush rest. This will keep pressure off of the bristles and prevent bends. Never leave the script liner in water for long periods of time or the next time you go to use it, the bristles will be curved. Another option is to wrap the brushes in a moist paper towel and put them into a plastic zip locking bag. Do not leave them like this for more than a day as heat and moisture can cause other problems.

TIP 7: Remember, the final results are only as good as the preparation. When painting on raw wood, sand, base coat and then lightly sand again. The first sanding is to smooth any rough areas, the second sanding is to "knock down" the wood grain that swelled up from the moisture of the basecoat. If you neglect to do this second sanding, you will have a rough-looking painting and a lot of headaches while you are painting. By taking the time to do a light sanding after the base coat has dried, you will have

a really smooth surface to paint on and a smooth finish as a result.

TIP 8: To help plan a design that will be symmetrical on two surfaces, use shadow leaves to lay out the shape. For instance, while painting an ivy swag on two doors of an entertainment center, I started with shadow leaves. This helped to lay out the placement, size and shape of the swags. After I was satisfied with the layout, I filled in with opaque leaves. Any shadow leaves that were slightly off were too light to be noticed.

TIP 9: While practicing your brushstrokes, try to break them down mechanically. In other words, think about the movement and the direction of the stroke. This will help you to be able to reverse the direction easier. For instance, when painting a one-stroke leaf pointing to the right, start with the brush at 12 o'clock, turn the top toward 1:30 and then slide toward 3:00. To paint a one-stroke leaf pointing to the left, start at 12:00 o'clock, turn to 10:30 and slide toward 9:00.

TIP 10: The color you see in your blending track is the color you will end up with on your surface. Sounds obvious, doesn't it? Surprisingly, beginner painters and some intermediate and advanced painters don't realize this. If you have muddy colors in your blending track, then you will have muddy colors on your surface. The blending track is extremely important! Take your time and look at it as you are loading and blending colors. Don't try to be fast while working it; instead make sure you are getting the results you want. The payoff will be worth it.

Painting Supplies

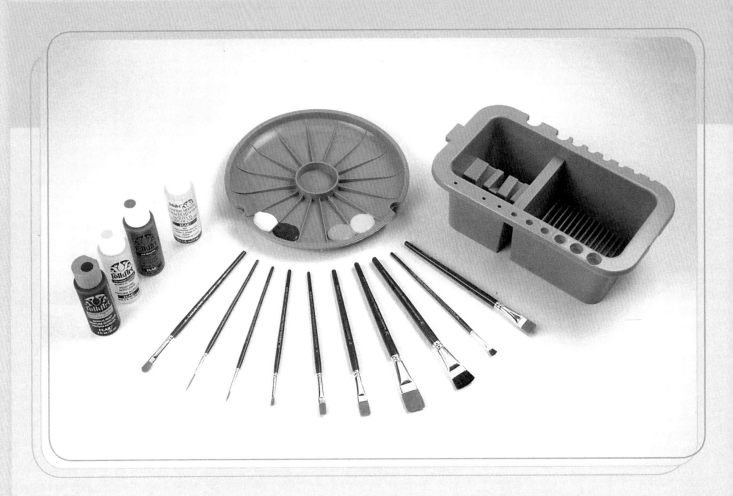

ACRYLIC PAINTS AND MEDIUMS

For all the painting demonstrations in this book, I'm using Plaid FolkArt Acrylic colors, Artists' Pigments, and Floating Medium. These are available at any arts and crafts supply store. They are high quality paints that come in handy 2-ounce (59ml) plastic squeeze bottles in a wide array of premixed colors. Floating Medium is a clear gel that allows your acrylic paints to stay wetter, which helps make your brushstrokes smoother without dry spots, dragging or breaks.

Acrylic paints are convenient and fun to use! They are odorless and water-based so there are no solvents needed. Clean-up is easy—just use water to rinse the paint out of your brushes while you're working, then use a gentle brush cleaning gel to clean and condition your brushes at the end of the day.

BRUSHES

Painting the one-stroke technique requires the use of flat brushes. I prefer the One-Stroke brushes made by Plaid. These brushes are specially designed with longer bristles to hold lots of paint, yet with a sharp chisel edge, which is essential because most one-stroke brushstrokes start and end on the chisel edge of the brush.

For the paintings in this book, we'll be using flats in size nos. 2, 6, 8, 10, 12 and 16, plus the 3/4-inch (19mm) flat. We'll also use the nos. 1 and 2 script liners, a no. 8 filbert, a 1/4-inch (6mm) scruffy, a 3/4-inch (19mm) scruffy, and a 1/2-inch (13mm) rake brush.

OTHER SUPPLIES

To complete my painting table, I always keep a brush caddy filled with water so I can rinse out my brushes as I work; a double-loading carousel to make brush-loading easier and quicker; and good quality paper towels for blotting excess water or paint from my brushes.

Master Color Chart

All the colors I used for the paintings in this book are shown here. These are FolkArt Acrylic colors and FolkArt Artists' Pigments, plus three Metallic colors. The Artists' Pigments are indicated by (AP) and the Metallic colors are indicated by (M) next to the color names below.

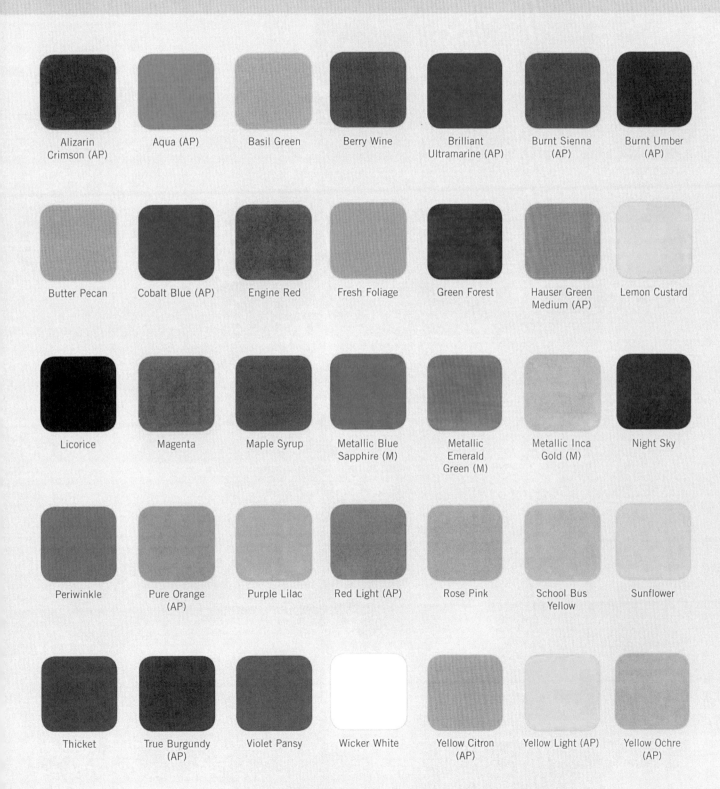

| Alizarin Crimson (AP) | Aqua (AP) | Basil Green | Berry Wine | Brilliant Ultramarine (AP) | Burnt Sienna (AP) | Burnt Umber (AP) |

| Butter Pecan | Cobalt Blue (AP) | Engine Red | Fresh Foliage | Green Forest | Hauser Green Medium (AP) | Lemon Custard |

| Licorice | Magenta | Maple Syrup | Metallic Blue Sapphire (M) | Metallic Emerald Green (M) | Metallic Inca Gold (M) | Night Sky |

| Periwinkle | Pure Orange (AP) | Purple Lilac | Red Light (AP) | Rose Pink | School Bus Yellow | Sunflower |

| Thicket | True Burgundy (AP) | Violet Pansy | Wicker White | Yellow Citron (AP) | Yellow Light (AP) | Yellow Ochre (AP) |

Essential One-Stroke Painting Techniques

DOUBLE LOADING THE BRUSH

1. Place the two colors you want to double load next to each other on the double-loading carousel. Leave an empty wedge next to them. Place some Floating Medium into the center circular well.

2. Set your brush into the two colors, straddling the wedge divider so the bristles are split in half. Press down and pull the brush toward you to pick up paint.

3. Move over to an empty wedge and work the paint into the bristles by stroking back and forth to blend the colors. Press down hard on the bristles to force paint into them.

4. Check your brush. This is how a correctly loaded brush will look. Note that the paint is two-thirds of the way up the bristles.

5. And this is how a double-loaded brushstroke will look on your painting. In one stroke, you have blended, highlighted and shaded.

MULTI-LOADING THE BRUSH

1. To load even more colors on your brush, place a third color in an empty wedge. Dip one corner of your double-loaded brush into this color. Load darker colors on the darker corner; lighter colors on the lighter corner.

2. Move over to the wedge where you blended your double-loaded brush and work the paint into the bristles by stroking back and forth to blend the colors.

3. And this is how a multi-loaded brushstroke will look. You can clearly see the darker red on one side, the lighter red in the middle, and the yellow on the other side.

USING FLOATING MEDIUM

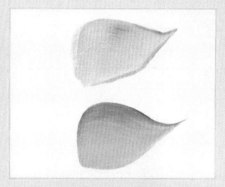

1. Using Floating Medium will help smooth out your strokes. Double load a flat brush with two colors as shown on the previous page. Dip the tip of the bristles into the Floating Medium in the center well.

2. Come back to the same blending wedge and work the medium into the brush by stroking back and forth.

3. The top leaf in this photo was painted without Floating Medium; the bottom leaf with. See how much smoother and more blended the bottom leaf is?

SIDELOADING AND FLOAT-SHADING

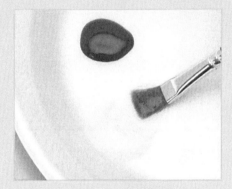

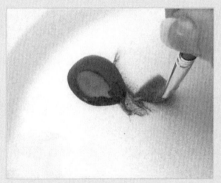

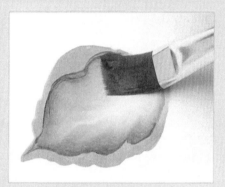

1. Sideloading means that you load only one corner of a flat brush with paint. Start by working some Floating Medium into the bristles. Since this is a clear gel, there is no color in your brush at this point.

2. Pull the brush through the edge of the puddle of paint. Stroke back and forth to load the color into one corner of the brush. Don't allow the color to creep over to the other side as you stroke.

3. Keeping the loaded side of the brush to the outside, float shading around the outer edge of your flower petal or leaf.

DOUBLE LOADING A FILBERT BRUSH

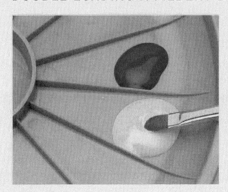

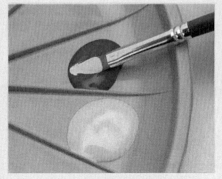

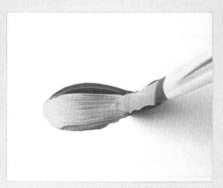

1. Double loading a filbert is different than double loading a flat brush because there are no corners. First, load one flat side of the filbert into the first color.

2. Flip the brush over to the other flat side and load into your second color.

3. When you stroke, the color that faces upward will be the dominant color. If you want the other color to be dominant, flip your brush over.

12 Brushstrokes to Practice

These are the fundamental brushstrokes you'll need to know to paint the One-Stroke technique. To begin practicing each of these brushstrokes, first double load a flat brush with two distinct colors. Each stroke can be used for many different things. For example, the chisel-edge stroke can be used to paint daisy petals as well as small fern leaves. Put five teardrop strokes in a circle and you have a five-petal flower. The pointed tip stroke can be a petal or a leaf. Keep practicing and experimenting!

CHISEL-EDGE STROKE

1. Double load a flat brush and start on the chisel edge.

2. Press down and pull to begin the stroke.

3. Lift back up to the chisel edge to form the pointed tip.

TEAR DROP STROKE

1. Start on the chisel edge. Press down so the bristles bend in the direction shown.

2. Press down more and pivot the red edge of the brush. Don't slide the bristles—just pivot them.

3. Lift back up to the chisel and slide to a point.

WIGGLE TEAR DROP

1. Start on the chisel edge. Press down so the bristles bend in the direction shown.

2. Wiggle the brush to form the wavy edge.

3. Lift back up to the chisel and slide to a point.

POINTED TIP STROKE

1. Start on the chisel edge, press down and begin to slide upward.

2. Slide straight up to the point as you release a little pressure on the brush, but don't lift the brush off the paper.

3. Without turning or pivoting the brush, slide back down to the base as you lift back up to the chisel edge to form a point, as shown at the base of the green leaf in the first photo.

WIGGLE-EDGE STROKE WITH A TURNED EDGE

1. Start on the chisel edge. Press down and wiggle up halfway on one side using lots of pressure.

2. Lift back up to the chisel and slide up to the tip.

3. Slide smoothly back down on the other side of the petal or leaf and roll the brush inward to form a turned edge. Lift to the chisel and slide to the base.

SHELL STROKE

1. Start on the chisel edge. Press down hard on the flat side so the bristles bend in the direction shown.

2. Wiggle out and slide back halfway. Wiggle out again and slide back halfway again. Pivot the brush as you wiggle.

3. Continue to wiggle out and slide back until the petal is the size you need. Finish by sliding back all the way to the base. If you want the outer edge to be the darker color as in photo one, just flip the brush.

ONE-STROKE LEAF AND PETAL

1. This stroke can be used for both leaves and petals. Start on the chisel edge and press down slightly at the base.

2. Put lots of pressure on the brush and turn the brush slightly.

3. Slide up to the tip as you lift back up to the chisel edge. Note how much the brush is turned compared with Step 1.

HEART-SHAPED LEAF

1. Touching lightly with the chisel edge, place two V-shaped guidelines for the top of the leaf and one for the stem. Begin the first half of the leaf at one of the V-shaped guidelines.

2. Press down and wiggle a shell stroke, pivoting on the inner corner of the brush, until you reach the stem guideline.

3. Keep pivoting the brush as you lift back up to the chisel and pull to the tip. Paint the other side of the leaf the same way, flipping your brush over to keep the darker green to the outside. Pull a chisel edge stem partway into the leaf's center.

SLIDER LEAF

1. I call this a "slider leaf" because your brush slides straight from the base to the tip. Start at the base, press down and begin to slide upward toward the tip.

2. Press down more and more on the brush to gradually widen the center part of the leaf.

3. Without turning or pivoting the brush, lift back up to the chisel edge to form the pointed tip.

FOLDED TULIP LEAF

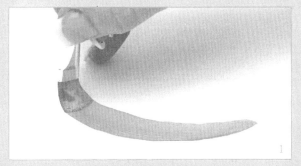

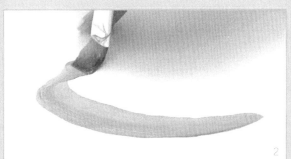

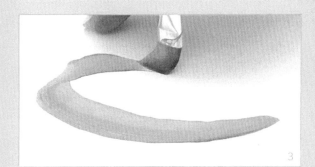

1. Start on the chisel edge at the base and stroke upward in a slight curve using the flat side of the brush. Keep the dark green to the outside edge.

2. Stand up to the chisel and turn the brush so the dark green side comes to the inside edge of the leaf.

3. Slide down on the flat side of the brush, then lift back up to the chisel for the pointed tip.

SEGMENTED LEAF

Some tulip leaves are segmented in the middle. Paint these the same as slider leaves, but release pressure on the brush to narrow the leaf, then reapply pressure to widen out again as you slide to the tip.

RIBBON STROKES

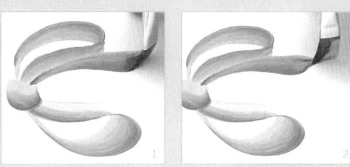

1. To paint ribbons that turn and twist, slide down on the flat side of the brush, leaning the bristles to the left side.

2. Stand up on the chisel where the ribbon turns to the edge.

3. Now lean the bristles to the right side and slide downward. Repeat these three steps for every turn of the ribbon. The knot is a large C-stroke.

Making Good Color Choices

LEAVES

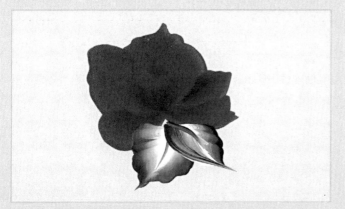

Poor Color Choices
The leaves are Green Forest and Wicker White, a combination which is too strong and competes with the Engine Red and Burnt Umber of the rose.

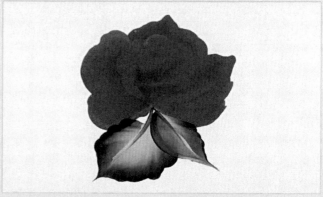

Good Color Choices
Here the rose colors are the same, but the leaves are softened and set back with Green Forest and Yellow Light. Now your attention is drawn to the rose, not the leaves.

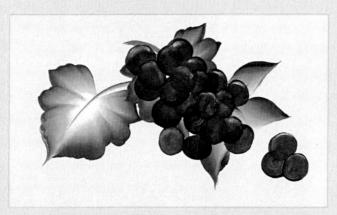

Poor Color Choices
Here again, the grape leaves of Green Forest and Wicker White pop out at you right away. The grapes are mostly Dioxazine Purple with some Violet Pansy, which is too dark and makes the grapes look flat.

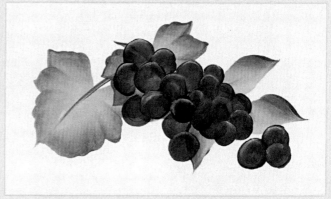

Good Color Choices
To make the grapes look rounded, use more Violet Pansy shaded with Dioxazine Purple. These leaves look more natural with Thicket, Wicker White and Lavender, which reflects the purple colors of the grapes.

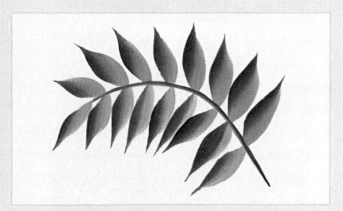

Poor Color Choices
Green Forest is too strong of a green to be combined with Italian Sage and makes these fern leaves look unnatural—almost like the fake plastic leaves you often see in artificial flower arrangements.

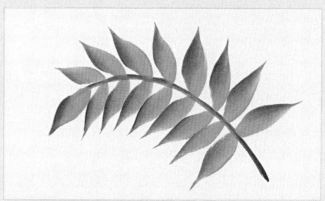

Good Color Choices
Fern leaves come in many shades of green but here is a good combination that will work well in many of your paintings—Italian Sage shaded with Thicket.

FLOWERS

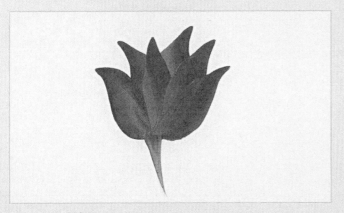

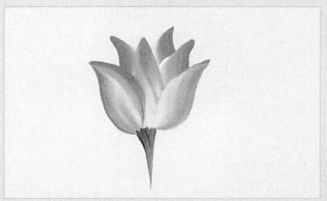

Poor Color Choices
Tulips come in lots of beautiful colors, but this garish combination of Engine Red and Magenta isn't one of them. It also doesn't relate to the stem colors of Thicket, Yellow Light and Wicker White.

Good Color Choices
Here's a much prettier tulip you'll find in many spring gardens. Same stem colors, but the petals are painted with a multi-load of Yellow Light, Wicker White and Magenta.

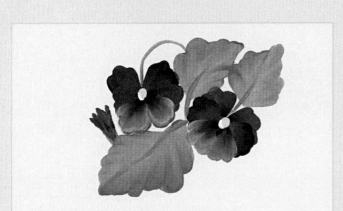

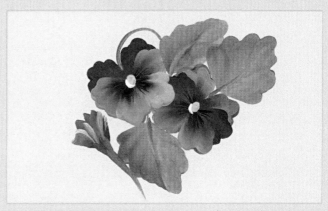

Poor Color Choices
These violas are dull and flat. The petals are painted with Violet Pansy and Dioxazine Purple and the centers with Sunflower and Wicker White. The leaves are Hauser Green Medium and Italian Sage.

Good Color Choices
In comparison, these violas are lively and colorful. The leaf colors are the same, but the petals are layered with Berry Wine, Lavender and Violet Pansy. The centers are brighter with Yellow Light and Wicker White.

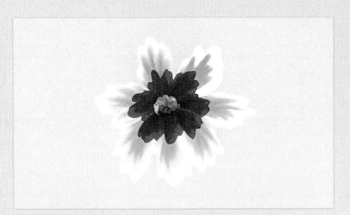

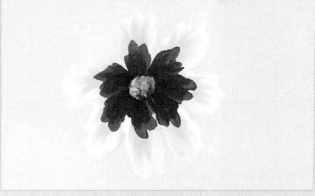

Poor Color Choices
Coreopsis, a yellow-flowered perennial with daisy-like petals, is naturally bright and sunny. But these colors are not. The petals above are Yellow Ochre, Wicker White, Engine Red and Burnt Umber.

Good Color Choices
Just changing the yellow on the petals from Yellow Ochre to Yellow Light brings this coreopsis closer to its true colors. The Yellow Ochre was reserved for the center to shade it and set it in deeper.

FRUITS AND BERRIES

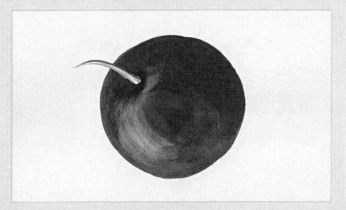

Poor Color Choices

The next time you have a red apple in your hand, study it to see how many colors are in the skin. This apple was short-changed: Alizarin Crimson, shaded with Burnt Umber and highlighted with Wicker White.

Good Color Choices

This apple looks fresh-picked off the tree! I used Alizarin Crimson to start, but shaded with True Burgundy and highlighted with Yellow Light and School Bus Yellow. The stem indentation is Burnt Umber.

Poor Color Choices

These raspberries look completely unnatural. Why? Because the basecoat is light in color (Magenta and Wicker White) and the seeds are dark (Violet Pansy, Alizarin Crimson and Dioxazine Purple).

Good Color Choices

To correct this problem, just switch it. Begin with a darker basecoat of Berry Wine and a little Dioxazine Purple. Paint the seed segments with lighter colors of Magenta, Wicker White and Violet Pansy.

Poor Color Choices

Like apples, pears have many colors in their skins. But this one looks dull and flat, with only Hauser Green Medium, Sunflower and Burnt Umber used for the skin, stem and blossom end.

Good Color Choices

Instead, begin with a basecoat of Yellow Ochre and Yellow Light, then use vertical strokes of Fresh Foliage and Yellow Citron for the green areas, and shade and shape with True Burgundy and Burnt Umber.

DETAILS

Poor Color Choices

The colors I use for bees are Yellow Light, Yellow Ochre, Licorice, and Wicker White. But sometimes bees can look like cartoons, with harsh stripes, heavy motion lines, stiff legs, and wings that are opaque.

Good Color Choices

Here I used the same colors but added Floating Medium to create wings that are soft and transparent, stripes and antennae that are fine and hairlike, and motion lines that are light and playful.

Poor Color Choices

When ribbons are used as accents or finishing touches in a painting, they need to blend in and not take attention away from the focal point. These Magenta and Wicker White ribbons are stiff and overbearing.

Good Color Choices

These ribbons are soft and flowing, and their colors will not detract from most compositions. I used Metallic Inca Gold and Metallic Peridot, but if you don't like metallics, try Sunflower and Thicket together.

Poor Color Choices

Poorly done flower centers can ruin your painting. The pink petals are Magenta and Wicker White, the centers are Thicket, Yellow Light and Wicker White, but the stamens look like candles on a birthday cake!

Good Color Choices

To fix it, keep the same colors, but base the center with Yellow Light, shade it with Thicket, then randomly tap on the stamens with Thicket, Wicker White and a little Yellow Light for some pollen dots.

Flowers

Red Roses

BRUSHES

no. 10 flat
no. 12 flat
no. 16 flat
no. 2 script liner

COLORS

Engine Red Berry Wine Burnt Umber Yellow Light Wicker White Green Forest

1. Using a no. 12 flat, double load Engine Red and Berry Wine, alternating with Burnt Umber for the darkest color, and paint the outermost layer of petals.

2. Paint the next layer of petals which are smaller and shorter, keeping the Engine Red side of the brush to the outside edge of the petals.

3. Place the center bud with an upside down U-stroke for the back of the bud and a U-stroke for the front. Chisel in two petals on either side of the bud.

4. Chisel in the front of the rose with two or three more petals, depending on how much space you have. With the same colors on a no. 10 flat, begin the sideview opening bud with the back layer of petals.

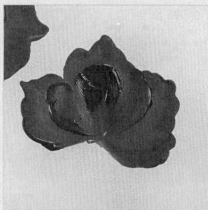

5. Add the center bud and the two side petals that curve around from the back and cross in front of the bud.

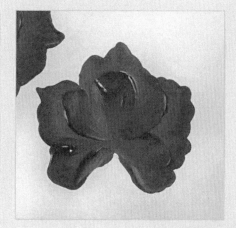

6. Finish the opening bud with two lower petals that hang down in front. Add the rose leaves with a double load of Yellow Light and Green Forest on a no. 16 flat. Pick up a touch of Wicker White occasionally to tone down the brightness of the yellow. Paint a few of the leaves in clusters of three. Add a closed bud and a calyx and finish with ten-drils painted with a no. 2 script liner.

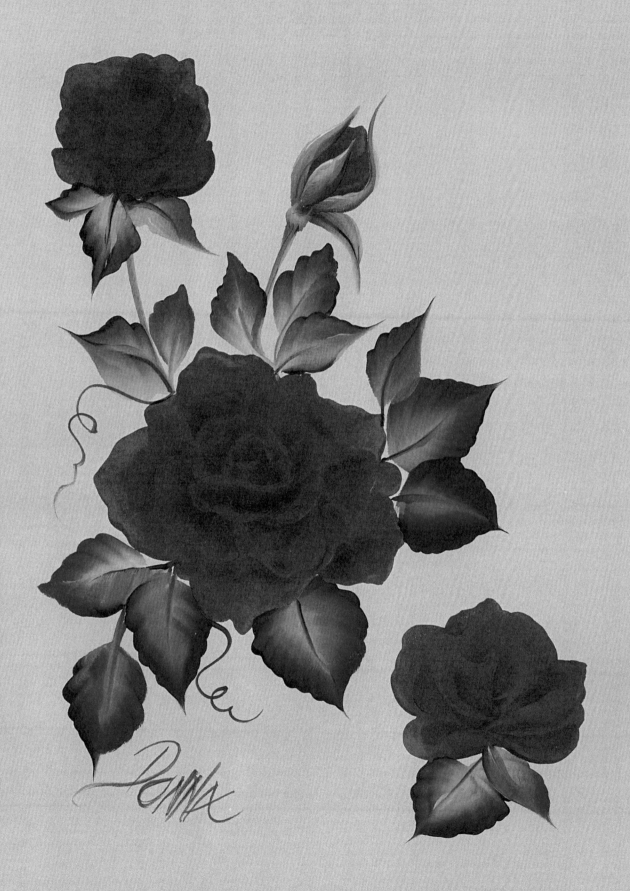

Lavender

BRUSHES

no. 8 flat
no. 2 script liner

COLORS

Thicket Wicker White Violet Pansy

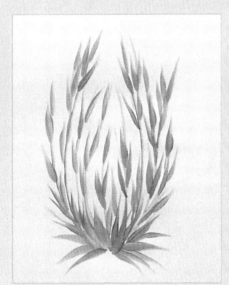

1. Double load Thicket and Wicker White on a no. 8 flat and place in the long slender leaves, clustered at the base, and extending upward from the stems.

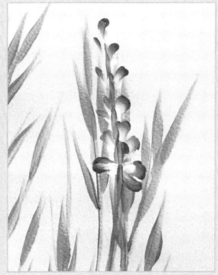

2. For the lavender petals, double load Violet Pansy and Wicker White on a no. 8 flat and begin with little teardrop strokes at the top of the stem.

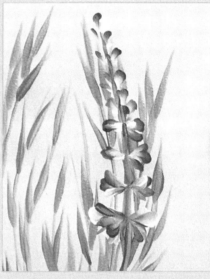

3. As you come down the stem, the petals open up into a more horizontal pairing. Allow quite a bit of stem to show between each pair. Lead with the Violet Pansy on some petals so they are lighter in color and give a layered look to the blossom.

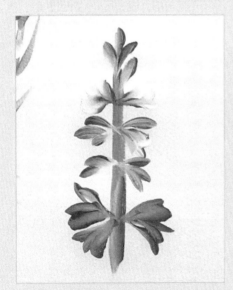

4. To paint the closeup detail of the lavender blossoms, load a no. 8 flat with Violet Pansy and pick up a tiny bit of Wicker White. Paint the back petals of the larger open petals.

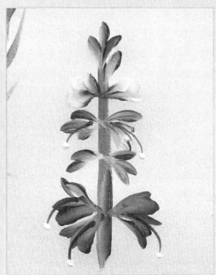

5. Use inky Violet Pansy on a no. 2 script liner to pull a long stamen out of each open flower. Dot a bit of Wicker White on the end of each stamen.

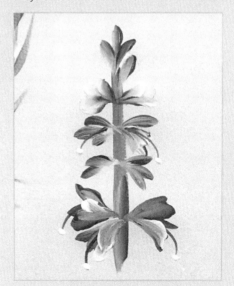

6. Go back to your no. 8 flat, pick up more Wicker White and pull the front petals. As you stroke, you'll pick up a little of the still-wet Violet Pansy you used for the back petals.

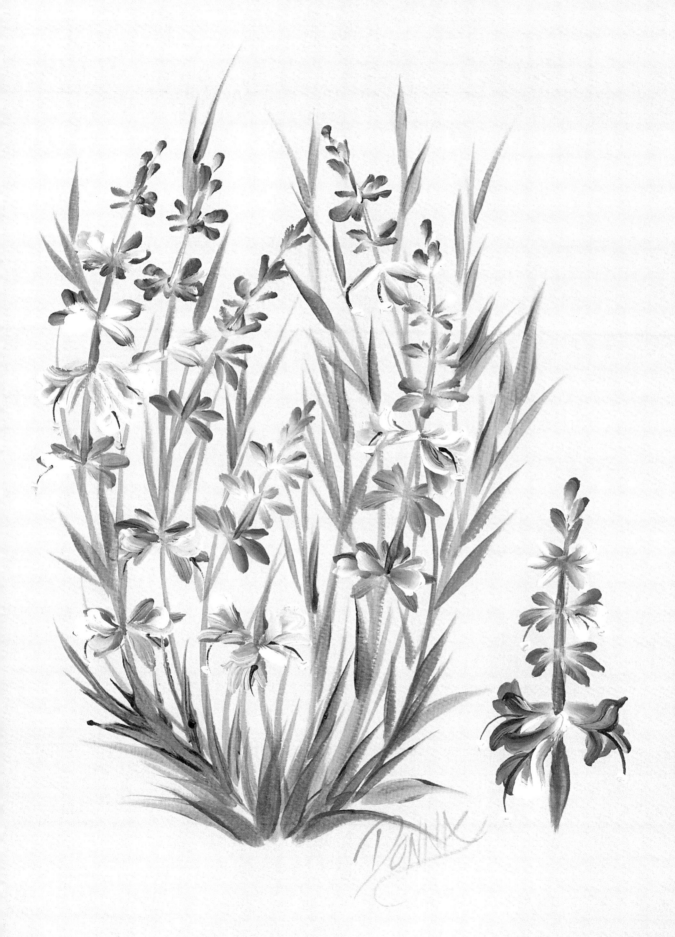

Coreopsis

BRUSHES

no. 8 flat
no. 10 flat
1/4-inch (6mm) scruffy

COLORS

 Hauser Green Medium
 Wicker White
Yellow Light
 School Bus Yellow
 Berry Wine
 Alizarin Crimson
 Thicket
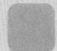 Yellow Ochre

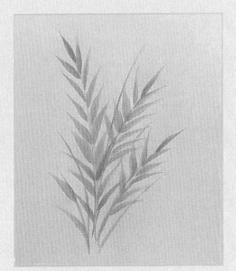

1. Double load Hauser Green Medium and Wicker White on a no. 10 flat and paint the main stems and long slender leaves of the coreopsis plant.

2. Begin the skirt of petals with a double load of Yellow Light and Wicker White on a no. 10 flat. Pick up a little School Bus Yellow on the yellow side of the brush to add depth and get better coverage.

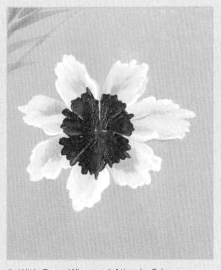

3. With Berry Wine and Alizarin Crimson double loaded on a no. 8 flat, paint the red color along the center part of each petal. Wiggle your brush on the outer edge of each red segment.

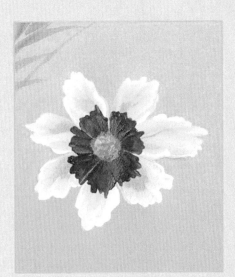

4. Pounce Hauser Green Medium and Thicket for the shaded lower part of the center using a 1/4-inch (6mm) scruffy. Pounce on highlights with Yellow Ochre and Yellow Light.

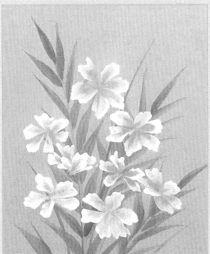

5. Fill in the coreopsis plant with more blossoms. Place them by first painting just the yellow and white petals using a no. 10 flat.

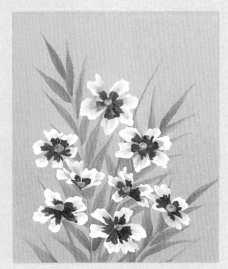

6. Switch to a no. 8 flat and paint the red "eye" in the centers of the yellow petals, then pounce on the centers just as you did in step 4.

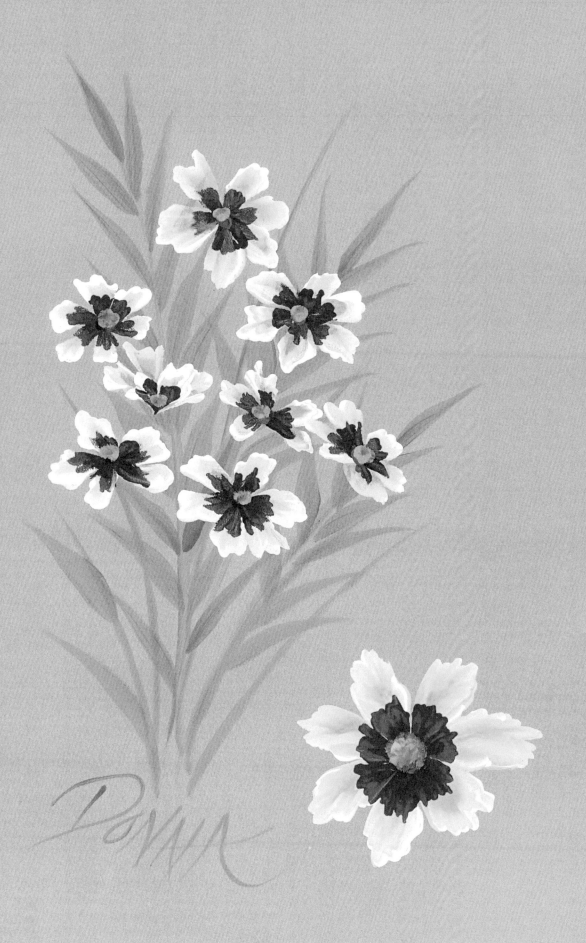

Bleeding Heart

1. With Hauser Green Medium and Thicket, plus a tiny bit of Yellow Light, use a no. 12 flat to place in the leaves and stems. Pick up a little Berry Wine for the little curving stemlets that the flowers hang from.

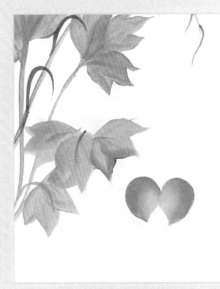

2. Double load Magenta and Wicker White on a no. 12 flat and begin the bleeding heart blossom with a heart shape. Add the white petal in the center.

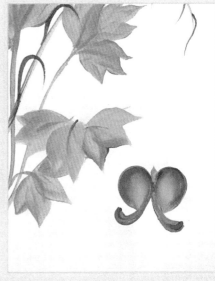

3. Load a no. 8 flat with Magenta and sideload into Berry Wine. Paint the curving edges of the petals and shade the outside edges of the heart shape. Paint a small green stroke for the base of the flower at the top.

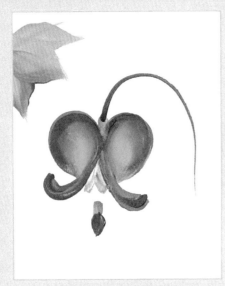

4. Shade the top of the white petal with Magenta and at the bottom, add a green segment and a dark Berry Wine tip. Pull a curving stemlet using Berry Wine and a no. 2 script liner.

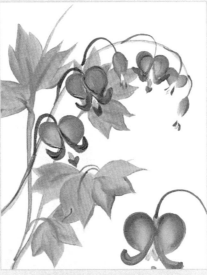

5. Fill in with more bleeding heart blossoms along the main vine using the same colors as in steps 2-4. Make some of them side views and some unopened buds for more interest.

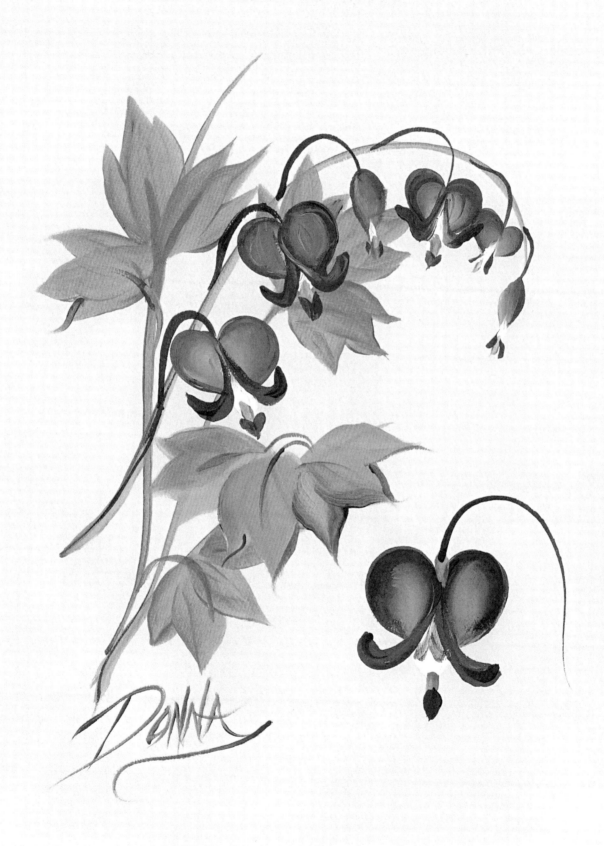

Blue Asters

BRUSHES

no. 6 flat
no. 10 flat
no. 12 flat
1/4-inch (6mm) scruffy

COLORS

Thicket Yellow Citron Wicker White Violet Pansy Pure Orange Yellow Light

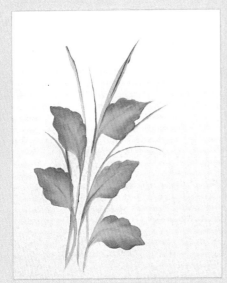

1. Double load Thicket and Yellow Citron on a no. 12 flat and pick up a little Wicker White. Place in the stem and paint the wavy-edged leaves.

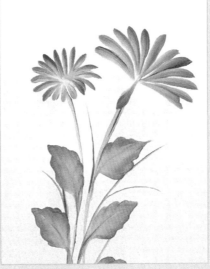

2. Double load Violet Pansy and Wicker White on a no. 12 flat and begin pulling the longer, upper petals of the blue asters.

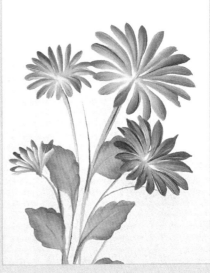

3. Pull the shorter front petals using the same brush and colors. Add two more blossoms, picking up more Violet Pansy to darken the one at lower right. Paint the small sideview bud following the instructions in steps 5-6.

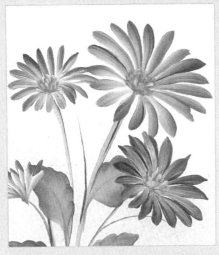

4. Load a 1/4-inch (6mm) scruffy with Pure Orange and pounce on the centers of the open flowers. Load a no. 6 flat with Pure Orange and sidestroke into Yellow Light. Leading with the orange side of the brush, pull tiny lines for the stamens.

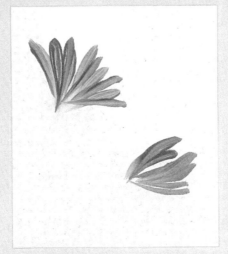

5. For the side view buds, begin with the back petals using Violet Pansy and Wicker White on a no. 10 flat. Pull downward toward the base leading with the Wicker White side of the brush.

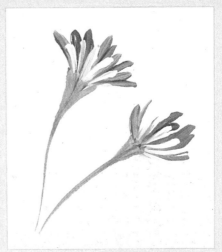

6. Pick up more Wicker White on the same brush and, leading with the Violet Pansy, pull the front petals of the buds. These should be shorter so the back petals can still be seen. Add the stems with a double load of Thicket and Yellow Citron on a no. 10 flat.

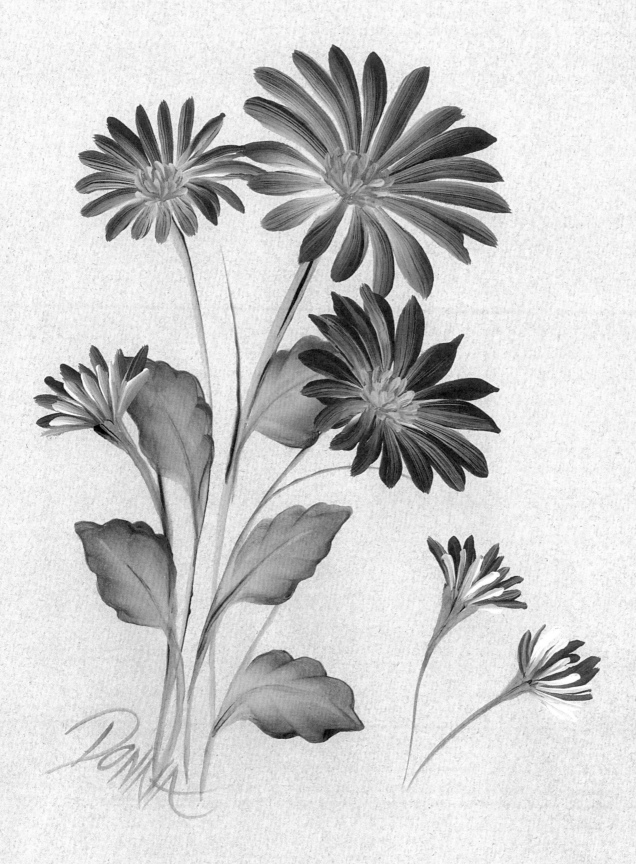

Honeysuckle

BRUSHES

no. 12 flat
no. 16 flat
no. 2 script liner

COLORS

Hauser Green
Medium

Wicker White

Yellow Light

Thicket

Alizarin
Crimson

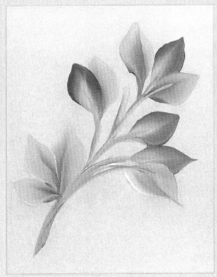

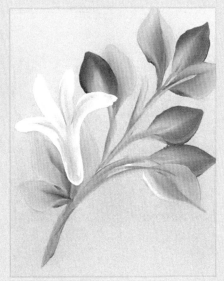

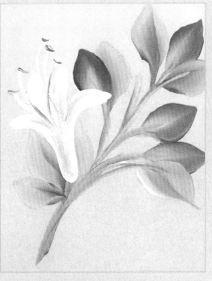

1. Double load Hauser Green Medium and Wicker White on a no. 16 flat. Pick up Yellow Light sometimes and Thicket sometimes as you stroke the leaves and place in the stems.

2. Double load Yellow Light and Wicker White on a no. 12 flat and begin the base of the trumpet shape. Your brush will pick up a little of the wet green paint from the leaves. Paint the large upward petals by stroking upward, curving around at the top, and stroking back down—a skinnier version of the trumpet base.

3. Load Wicker White and Yellow Light on the no. 2 script liner and pull long, threadlike stamens. The pollen dots on the ends are Alizarin Crimson and Yellow Light. Shade the stamens with one of the greens if they don't show up well against the white.

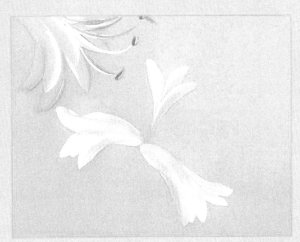

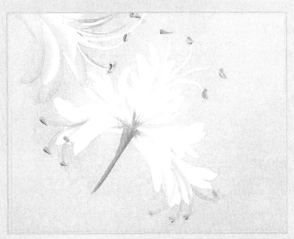

4. Here's another kind of honeysuckle to paint—the petals are thinner and more numerous. Double load a no. 12 flat with Yellow Light and Wicker White and begin the larger 3-part petals with trumpet shapes that are longer and skinnier than the ones shown in Steps 2 and 3.

5. Fill in with more long, skinny petals that stand upright. Double load Yellow Light and Hauser Green Medium and pull a stem from the base. Use a no. 2 script liner and Yellow Light and Wicker White to pull long stamens, then dot the pollen on with Alizarin Crimson and Yellow Light.

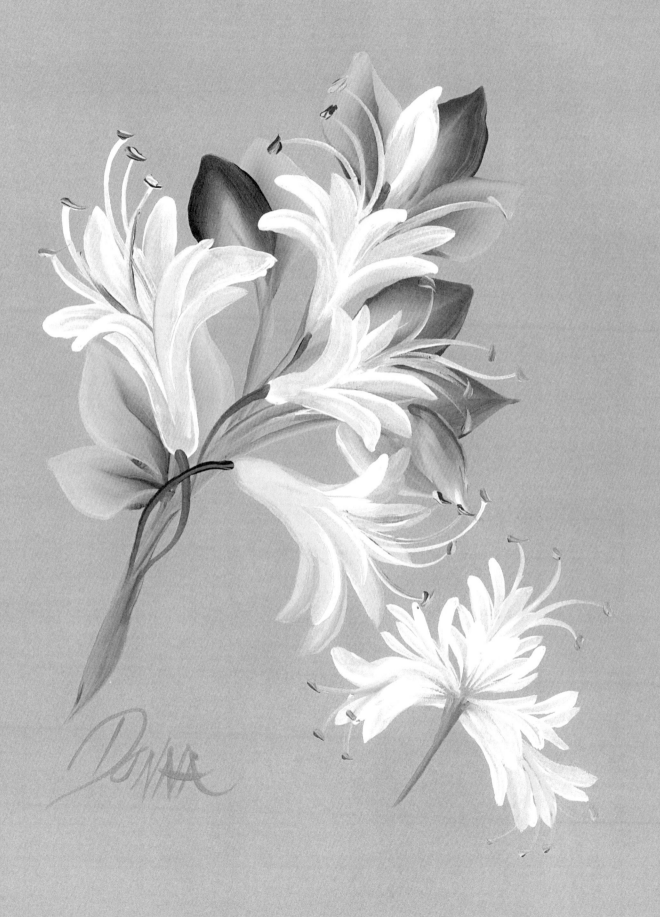

Mixed Tulips

COLORS

Yellow Citron Thicket Wicker White Engine Red School Bus Yellow Berry Wine Violet Pansy Pure Orange

1. Multi-load a no. 16 flat with Yellow Citron and Thicket, with some Wicker White on the yellow side, and paint the tall, sword-like leaves, pulling upward from the base to the painted tip.

2. Begin the bright red tulip with Engine Red, sideloaded into School Bus Yellow on a no. 12 flat. Paint the tulip shape in three separate petals and add a curved line beneath to act as a guide.

3. Add two more outer petals following the curved guideline. Note that the petal on the left has a turned edge; roll your brush inward as you slide down from the tip to the base.

4. Shade the base and separate the petals using Berry Wine on a no. 8 flat. Pick up a little School Bus Yellow on the same brush and clean up and define the pointed tip of each petal. Don't overblend—let the yellow edges remain distinct from the dark red of the petals.

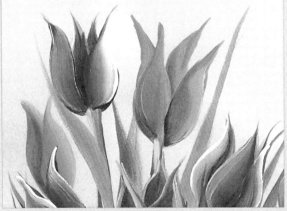

5. Paint the purple tulips the same way using Violet Pansy and Wicker White, and the orange tulips using Pure Orange and School Bus Yellow.

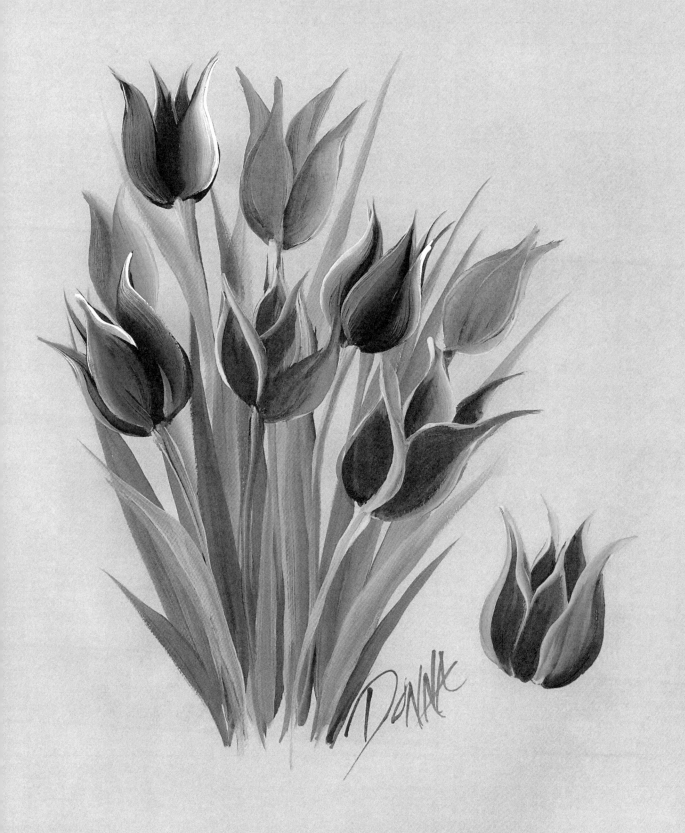

Mountain Laurel

BRUSHES

no. 8 flat
no. 10 flat
no. 12 flat
no. 2 script liner

COLORS

Thicket Yellow Citron Wicker White Magenta Burnt Umber

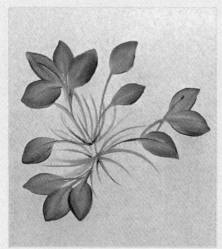

1. Double load a no. 12 flat with Thicket and Yellow Citron. Place the main stems and the oval shaped leaves. Draw in the smaller stems using the chisel edge.

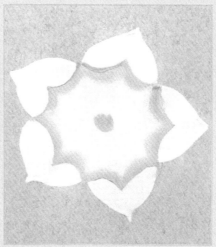

2. To paint the blossom, begin with the five large petals of Wicker White using the edge of the brush to draw the petal shape. Using the same brush that has Wicker White in it, sideload into Yellow Citron and paint the inner green part.

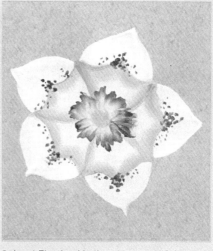

3. Load Floating Medium into a no. 8 flat and sideload into Magenta. Paint a ruffly pink circle around the center. Take a clean brush, load with Floating Medium and sideload into Yellow Citron. Pull five green rib lines down toward the center. Pepper the white petals with Magenta on the tip of a no. 2 script liner.

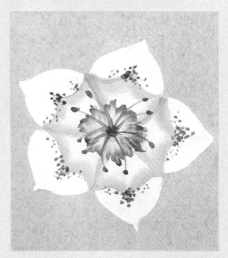

4. Load Yellow Citron on a no. 2 script liner and pull stamens out from the center. Dot the center and the outer tips of the stamens with Magenta.

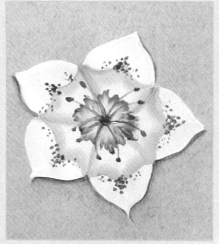

5. Load a no. 10 flat with Floating Medium and sideload into Burnt Umber. Float-shade around most of the white edges of the petals. Fill in the finished design with as many flowers as you like.

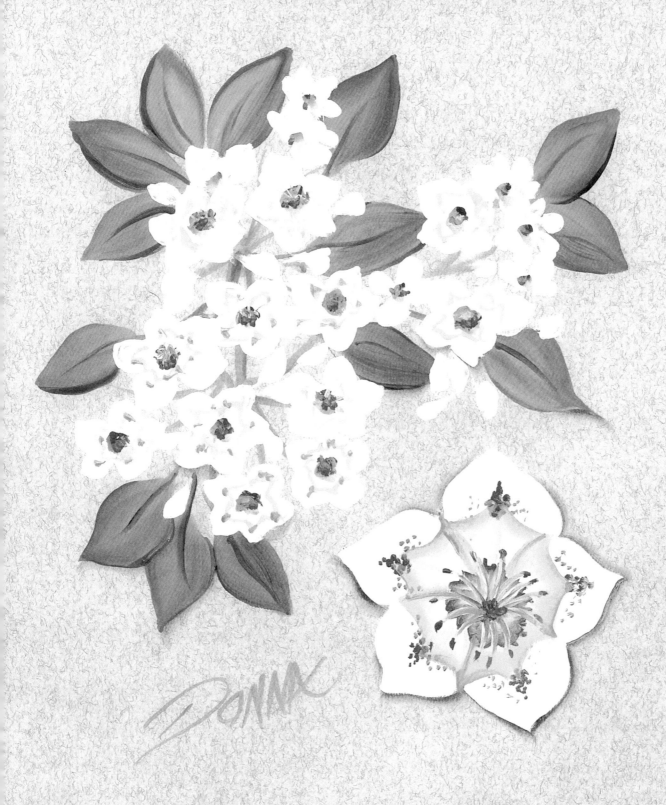

Spanish Bluebells

BRUSHES

no. 6 flat
no. 12 flat
no. 2 script liner

COLORS

Green Forest · Yellow Citron · Thicket · Violet Pansy · Wicker White · Periwinkle

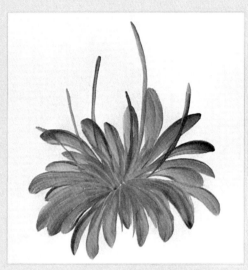

1. Place in the rosette of leaves at the base using Green Forest and Yellow Citron on a no. 12 flat. Pick up some Thicket to calm down the Green Forest slightly. Pull long chisel-edge stems upward from the rosette.

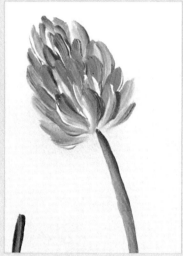

2. Double load a no. 6 flat with Violet Pansy and Wicker White and paint the upper part of the flower with short chisel-edge strokes to form the closed bells. Alternate picking up Periwinkle sometimes instead of Violet Pansy for color variation.

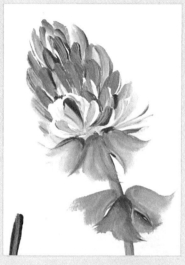

3. Add a few strokes with more Wicker White in your brush. Then begin forming the open bells that hang downward from the stem using the same three colors.

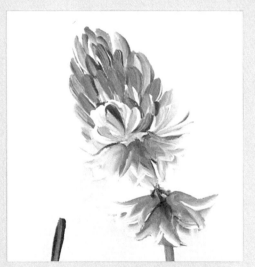

4. Define the serrated edge of each bell with more Wicker White on the same no. 6 flat. Fill in the design with more bluebells in various stages of development. Allow the green stem to show in between the open bells.

5. This sideview shows how a tiny stemlet attaches the bluebell to the main stem. Paint these stemlets with Thicket on a no. 2 script liner.

Orchids

BRUSHES

no. 6 flat
no. 12 flat
no. 16 flat
3/4-inch (19mm) flat
no. 2 script liner

COLORS

Green Forest

Yellow Light

Wicker White

Alizarin Crimson

Berry Wine

Yellow Ochre

1. Double load Green Forest and Yellow Light, plus a little Wicker White, on a 3/4-inch (19mm) flat. Paint the long slender leaves and stems.

2. Double load Yellow Light and Wicker White on a no. 16 flat and paint the three back petals of the orchid.

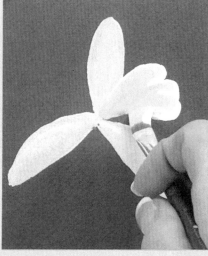

3. Begin the ruffled-edge side petals with a lot of Yellow Light, plus some Wicker White on the edge of the brush. Keep the white edge of the brush to the outside edge of the ruffled petal.

4. Add the other ruffled petal the same way. Turn your work upside down to make it easier to stroke on this side. Be sure there's enough white on your brush to separate these petals from the three in back.

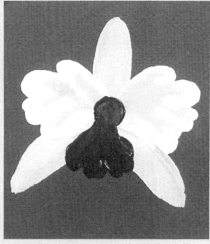

5. Paint the lower petal and center throat with Alizarin Crimson and Berry Wine on a no. 12 flat.

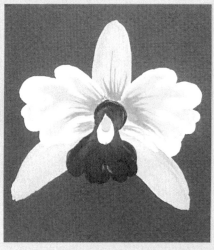

6. Use inky Yellow Ochre on a no. 2 script liner to shade around the center by pulling fine lines on the bases of the petals around the red area. Load a no. 6 flat with Wicker White and paint the stamen as a teardrop shape, then add a smaller Yellow Light teardrop shape to the center of the white one.

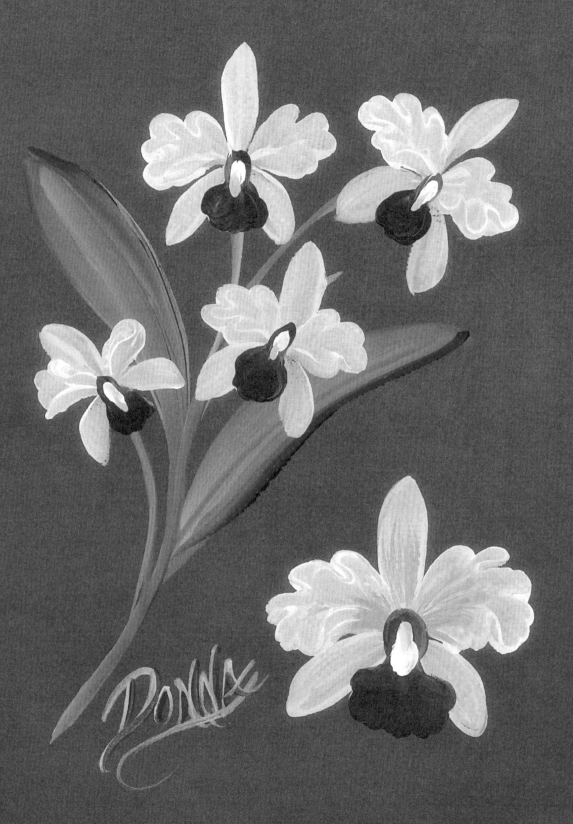

Pinks

BRUSHES

no. 6 flat
no. 12 flat
no. 2 script liner

COLORS

Thicket Yellow Citron Magenta Wicker White Yellow Light

1. Place in the stems and long slender leaves with a double load of Thicket and Yellow Citron on a no. 12 flat. Begin placing in the flowers at the tops of the stems using Magenta and Wicker White.

2. Fill in with more blossoms and pull fine stems up to each blossom with the two greens you used in step 1.

3. Here's a closeup look at how to paint the individual blossoms: Double load Magenta and Wicker White on a no. 12 flat and paint individual segments using the ruffled-edge brushstroke. After ruffling, pull the brush toward the center to finish each segment.

4. Complete the petal skirt. There are five petal segments that overlap slightly at each edge, but here and there, allow the segments to separate for a more natural look.

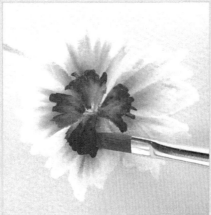

5. Load a no. 6 flat with Floating Medium and sideload into Magenta. Darken the base of each petal with a smaller ruffled-edge stroke.

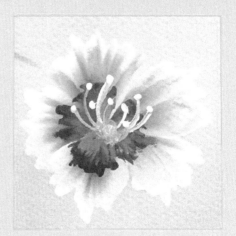

6. Place in the center with Yellow Light, then pull fine lines for stamens using the no. 2 script liner. Dot on the pollen with Wicker White. Continue adding the centers to all the blossoms in the cluster that are open and facing the viewer. The centers of the closed buds and sideview blossoms are not visible.

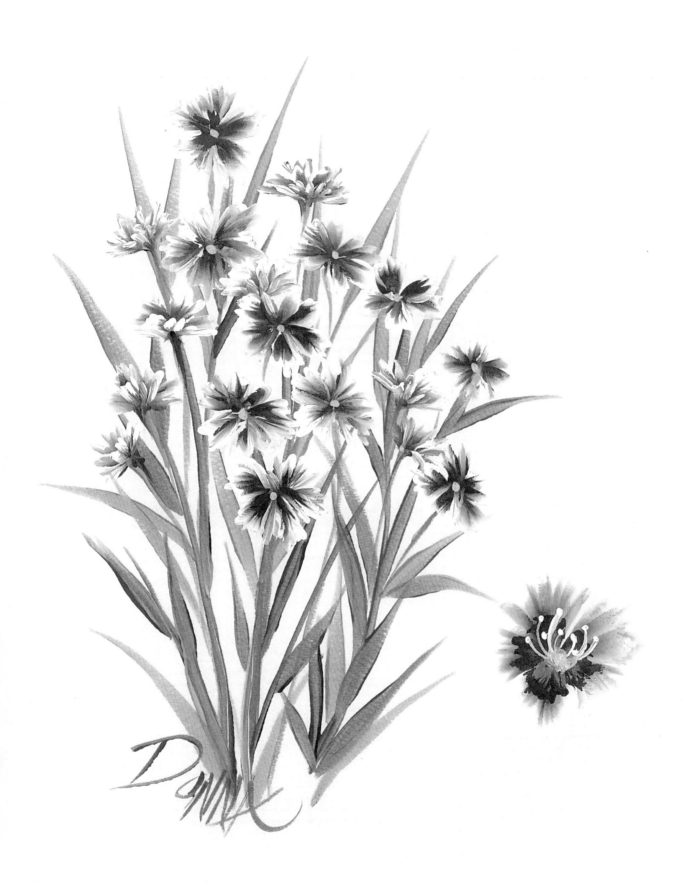

Russian Sage

BRUSHES

no. 2 flat
no. 12 flat

COLORS

Thicket

Wicker White

Periwinkle

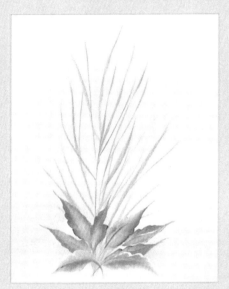

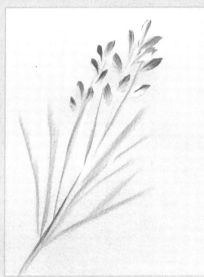

1. Place large leaves at the base of the plant using Thicket and Wicker White double loaded on a no. 12 flat, then pull long skinny stems upward out of the base using the chisel edge of the brush and very light pressure, especially on the thinnest stems.

2. Double load Periwinkle and Wicker White on a no. 2 flat. Begin painting the tiny blossoms using a touch and lift motion. Vary the colors by picking up more Periwinkle sometimes and more Wicker White other times.

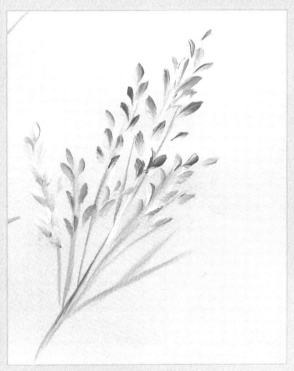

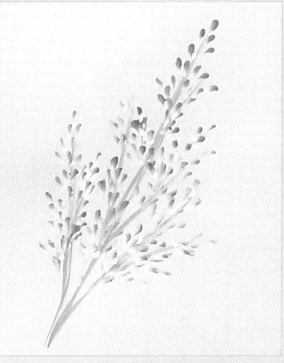

3. Keep adding petals down each stem and vary the color as often as possible.

4. Fill in each stem with these tiny petals until the entire sage plant is completed.

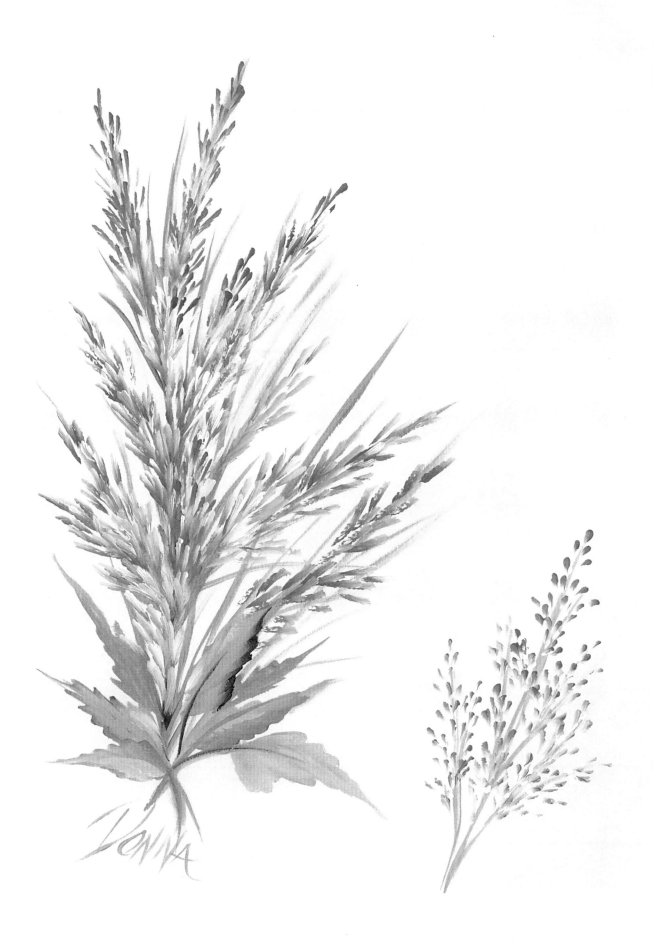

Blanket Flower

BRUSHES

no. 12 flat
no. 2 script liner
1/4-inch (6mm) scruffy

COLORS

Thicket

Sunflower

Green Forest

Pure Orange

Yellow Light

Wicker White

Red Light

Maple Syrup

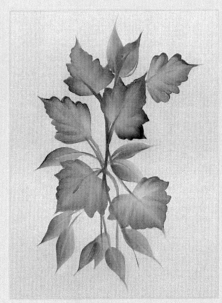

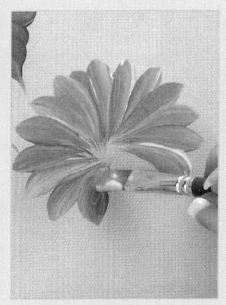

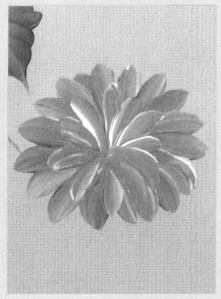

1. Double load Thicket and Sunflower with a touch of Green Forest on a no. 12 flat and place in the main stems and leaves.

2. Double load Pure Orange and Yellow Light on a no. 12 flat and pick up a little Wicker White on the yellow side. Begin pulling petals by starting at the outside and pulling your stroke in toward the center.

3. Add a second layer of shorter petals around the center, picking up a little more Yellow and White on the brush to separate the layers and highlight the petals.

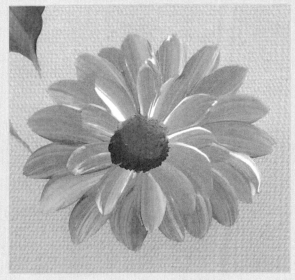

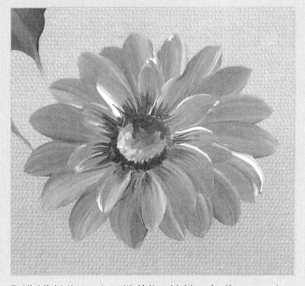

4. Begin pouncing in the center using Red Light on a 1/4-inch (6mm) scruffy. Sideload into a little Maple Syrup to shade the lower front edge.

5. Highlight the center with Yellow Light and a tiny amount of Wicker White on a 1/4-inch (6mm) scruffy. Shade the base of the petals around the center with Maple Syrup on a no. 2 script liner, pulling fine lines outward.

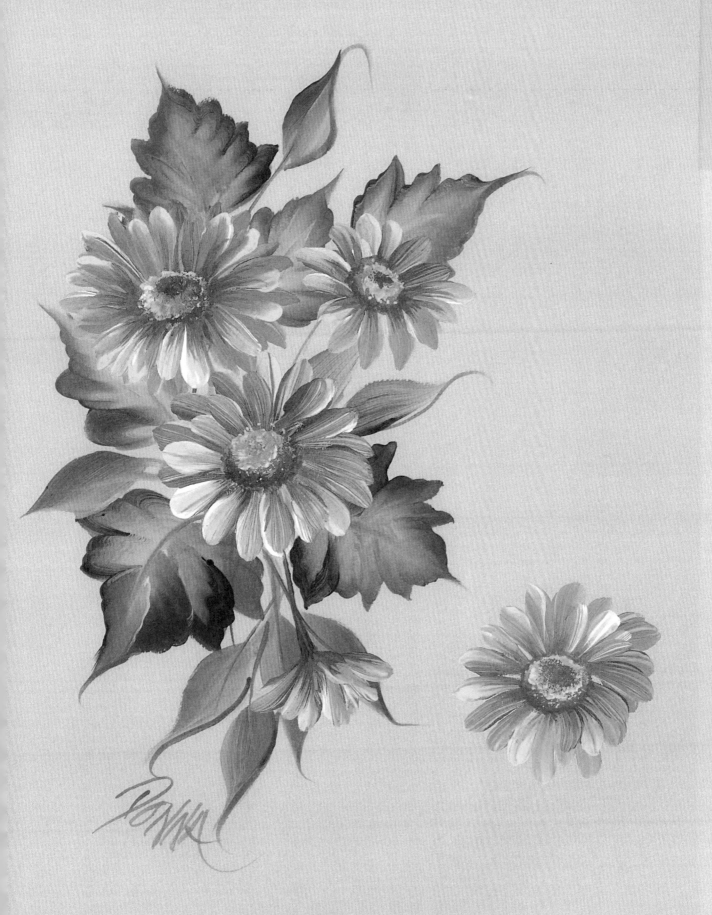

Viola

BRUSHES

no. 12 flat
no. 16 flat
no. 2 script liner

COLORS

 Fresh Foliage

Wicker White

 Violet Pansy

 Berry Wine

Purple Lilac

 Night Sky

Yellow Light

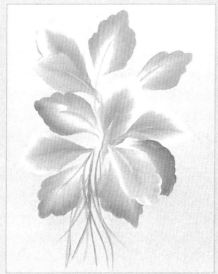

1. Double load a no. 16 flat with Fresh Foliage and Wicker White. Place in the ruffled-edge leaves and pull fine stems. Keep these leaves light in color to contrast better with the darker flower colors.

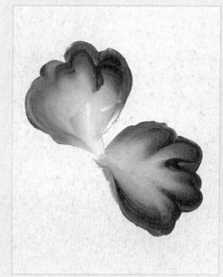

2. Double load Violet Pansy and Wicker White and pick up Berry Wine on the Violet Pansy side. Paint the two upper back petals, ruffling the outside edge.

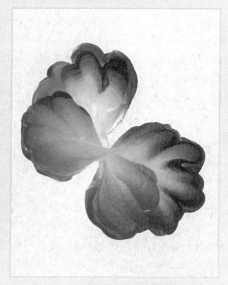

3. Double load Purple Lilac and Violet Pansy and paint the next two petals down, ruffling the outer edge only slightly.

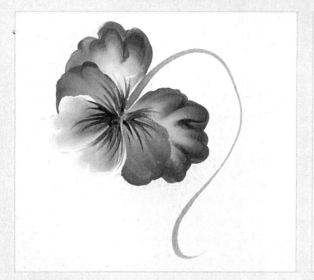

4. The last two petals are Berry Wine and Purple Lilac with a little Wicker White. Paint a green stem using inky Fresh Foliage, and pull fine whisker lines with Night Sky on a no. 2 script liner.

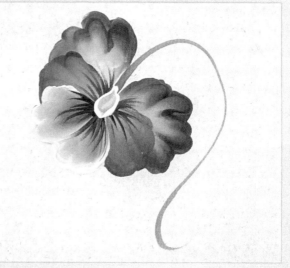

5. The center teardrop shape is Wicker White on a no. 2 script liner, with a smaller Yellow Light teardrop shape inside. Finish the design with more violas and a few buds here and there.

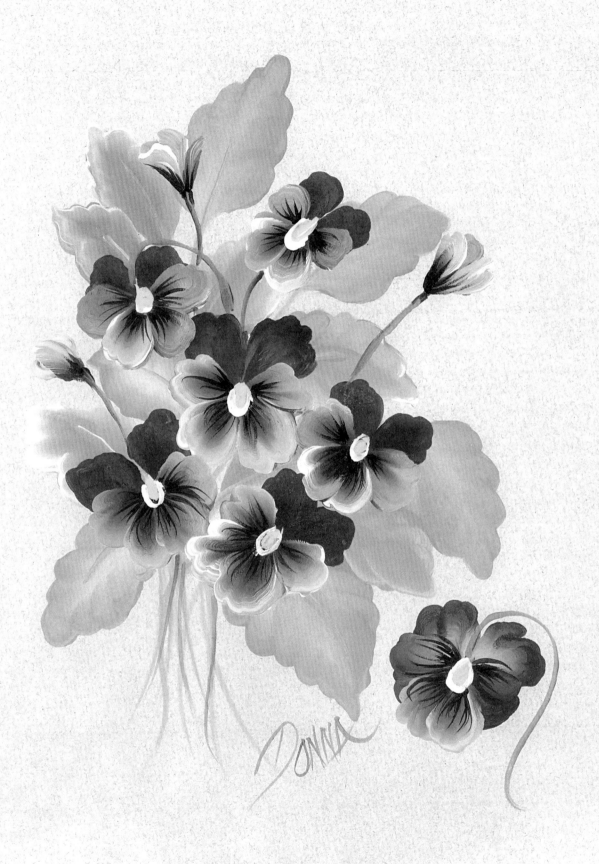

Shrub Roses

BRUSHES

no. 12 flat
3/4-inch (19mm) flat
1/4-inch (6mm) scruffy
no. 2 script liner

COLORS

Thicket Yellow Citron Magenta Wicker White Yellow Light Yellow Ochre

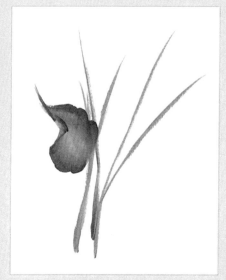

1. Double load a no. 12 flat with Thicket and Yellow Citron and paint the stems and a leaf with a folded edge.

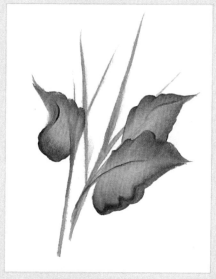

2. Add two more leaves, then pull chisel edge stems partway into each leaf. We'll add more leaves later after the roses are placed in the design.

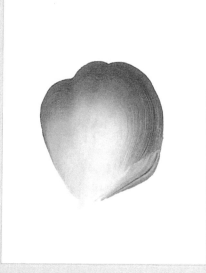

3. Double load a 3/4-inch (19mm) flat with Magenta and Wicker White; add a touch of Yellow Light to the white side and blend well. Using the flat side of the brush and keeping the Magenta to the outside, paint each petal with a slightly ruffled outer edge.

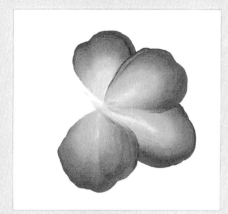

4. Add more petals, connecting them in the center and overlapping them somewhat. Keep the Magenta side of the brush always to the outside edges.

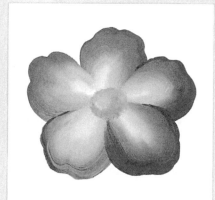

5. Double load a 1/4-inch (6mm) scruffy with Yellow Light and Yellow Ochre. Using a pouncing motion, paint the center of the flower. The Yellow Ochre is the shading color along the front edge.

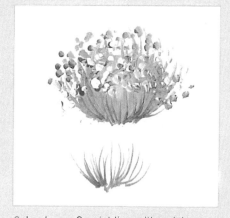

6. Load a no. 2 script liner with an inky mixture of Thicket and water. Using the tip of the bristles and a light touch, flick the brush up and out from the bottom edge of the center to create stamens. With a clean liner, dot on the anthers using Wicker White, Yellow Ochre and Magenta.

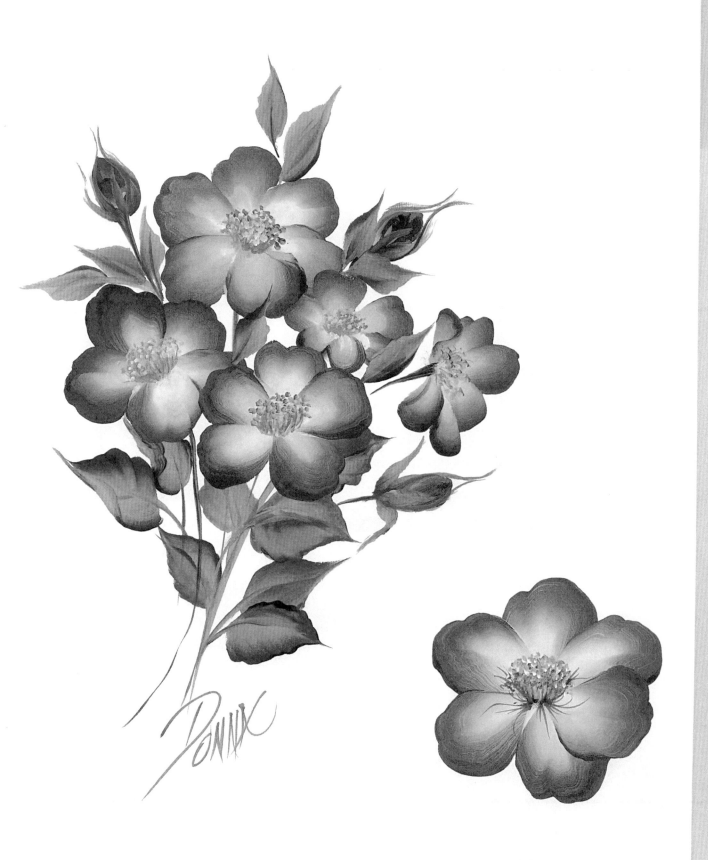

Mixed Wildflowers

BRUSHES

no. 2 flat, no. 8 flat, no. 10 flat
& no. 12 flat

COLORS

| Thicket | Yellow Citron | Brilliant Ultramarine | Wicker White | Yellow Ochre | Yellow Light | Red Light | Engine Red | Licorice |

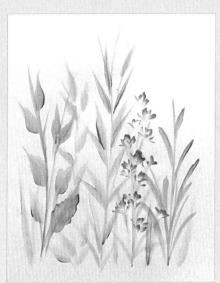

1. Place in a variety of leaves and stems, some more detailed for the foreground, others just suggested for the background. Use a double load of Thicket and Yellow Citron on a no. 12 flat. With a no. 8 flat, double load Brilliant Ultramarine and Wicker White and stroke in the petals of the blue flowers.

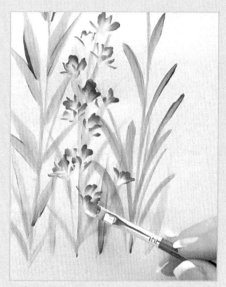

2. Stay up on the chisel edge to pull each little petal. The blue side of the brush shapes the upper edge, then the white side leads as you pull the stroke downward.

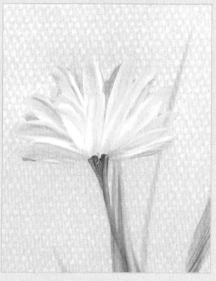

3. Double load Yellow Ochre and Yellow Light on a no. 8 flat and paint a bright yellow daisy. Pick up Wicker White sometimes and Yellow Light other times to vary the petal colors.

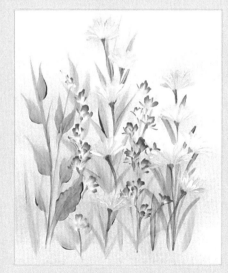

4. Fill in with more bright yellow flowers, placing some at the top of the stems and others in among the stems and leaves.

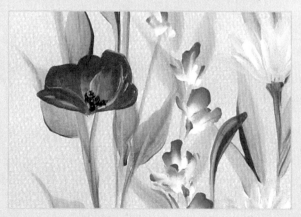

5. Load a no. 10 flat with Red Light, sidestroke into Engine Red and paint a large poppy flower. Pick up a little Yellow Light on the lighter side of the brush to help define the petals. Pick up Licorice on a no. 2 flat and tap in the black center stamens. Fill in with more red poppies among the yellow and blue flowers to make your painting look like a meadow of wildflowers.

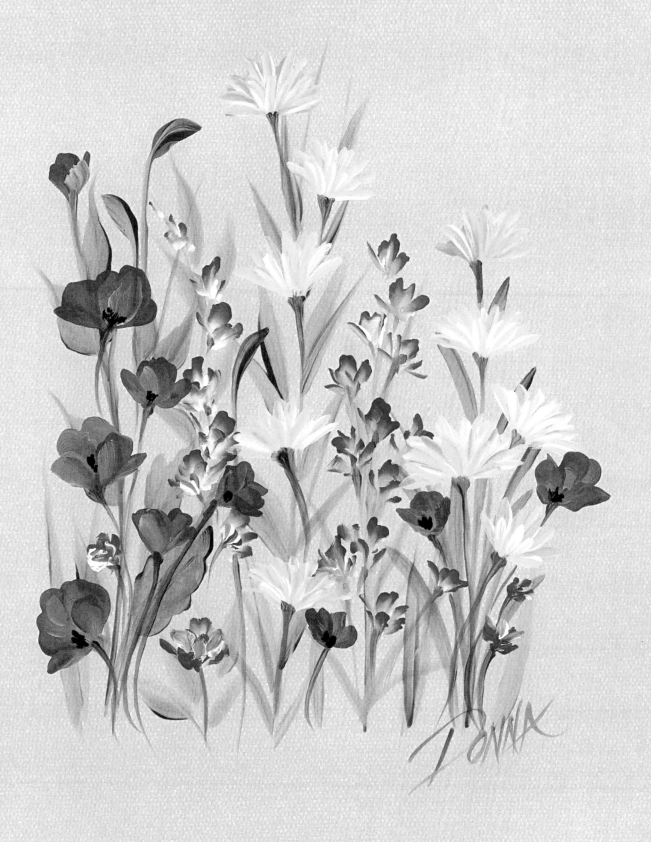

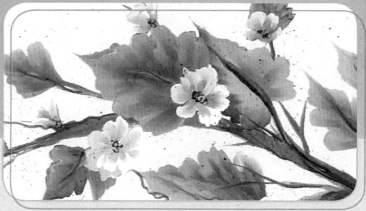

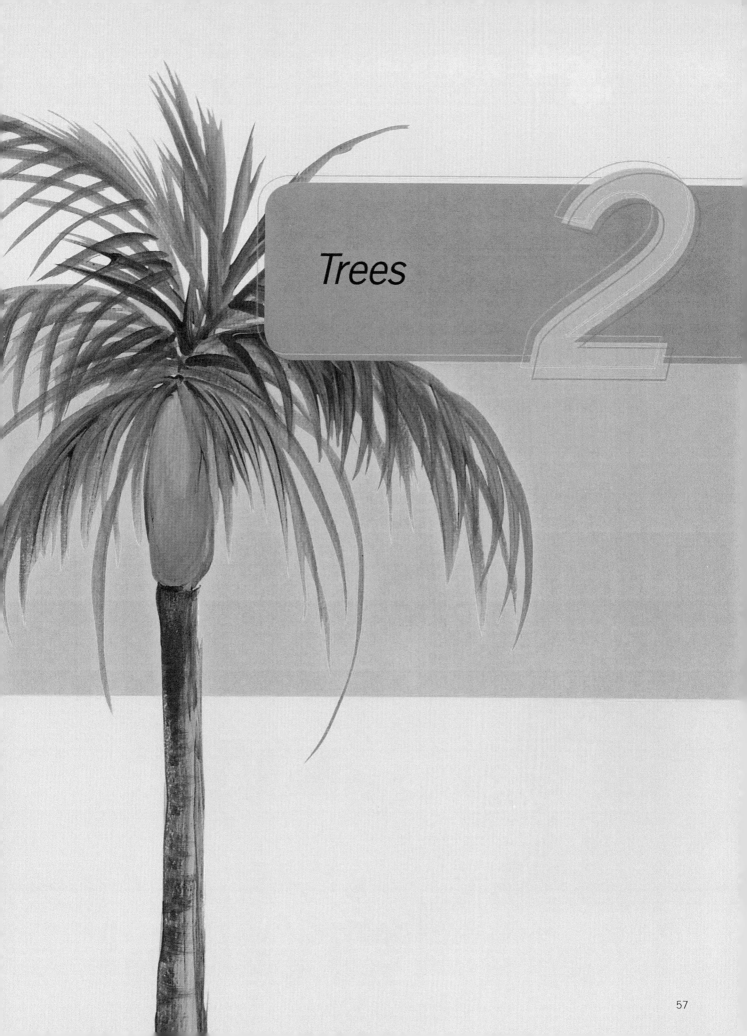

Trees

2

Hickory Tree

BRUSHES

no. 10 flat
no. 12 flat
3/4-inch (19mm) scruffy

COLORS

Burnt Umber

Wicker White

Thicket

Yellow Citron

Butter Pecan

Burnt Sienna

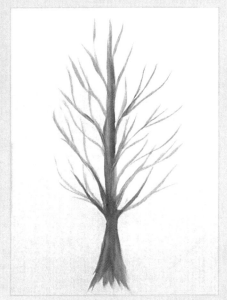

1. Using Burnt Umber and Wicker White on a no. 10 flat, paint the trunk and branches.

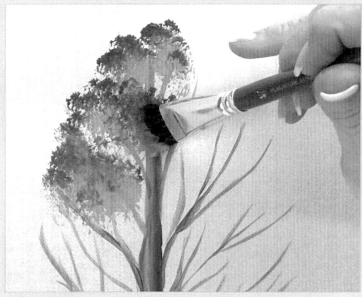

2. Double load Thicket and Yellow Citron on a 3/4-inch (19mm) scruffy and begin pouncing on the foliage starting at the top.

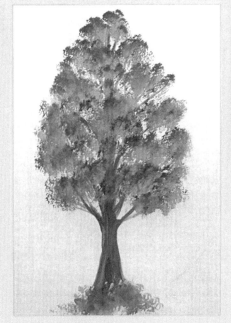

3. Finish pouncing on the foliage, allowing the trunk and branches to show through. Texture the trunk with a little Butter Pecan and Burnt Sienna, and add foliage at the bottom.

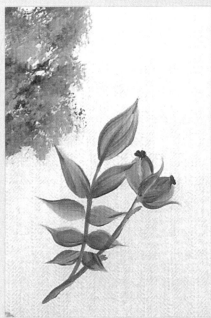

4. The hickory nut pods and stems are painted with Butter Pecan and Burnt Sienna. The leaves are Thicket and Yellow Citron on a no. 12 flat.

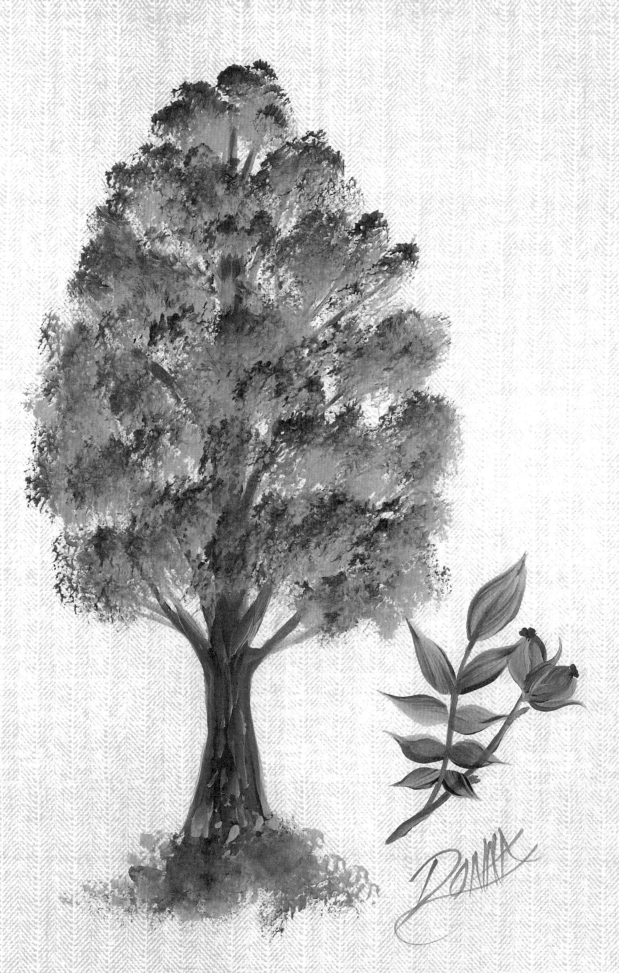

Maple Tree

COLORS

Burnt Umber Wicker White Yellow Light Engine Red Yellow Citron Thicket

1. Place in the trunk and branches with Burnt Umber and Wicker White using a no. 10 flat.

2. Using the same dirty brush, pick up Yellow Light and tap on clusters of yellow leaves using the flat side of your brush.

3. Using the same dirty brush, pick up Engine Red and tap on clusters of red leaves.

4. Using the same dirty brush, pick up Yellow Citron and a little Thicket and add clusters of green leaves. The single leaf is painted with a no. 12 flat and Yellow Light, working in Engine Red to make a red-orange. Define the edges and veins with Engine Red.

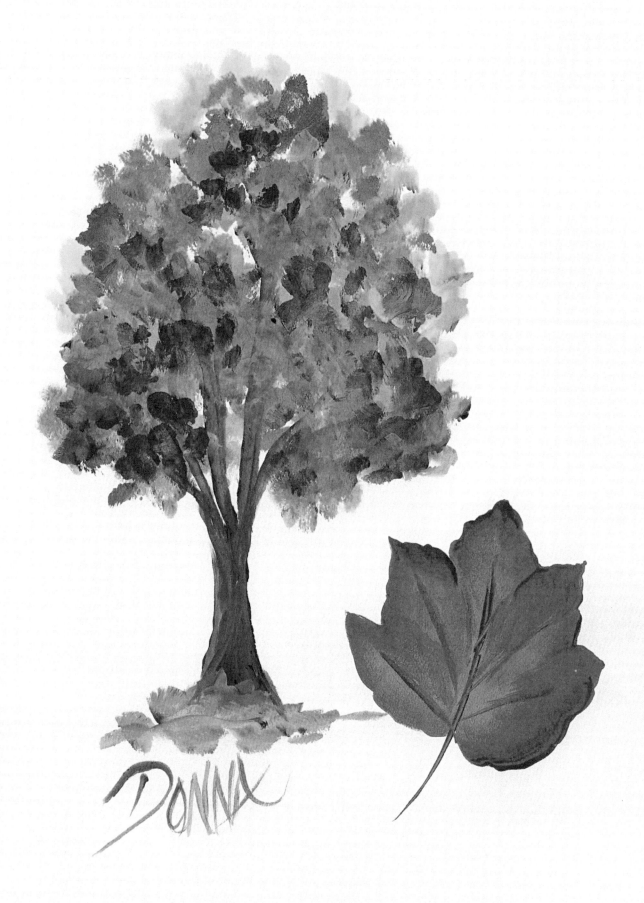

DONNA

Willow Tree

COLORS

Burnt Umber Wicker White Hauser Green Medium Yellow Citron

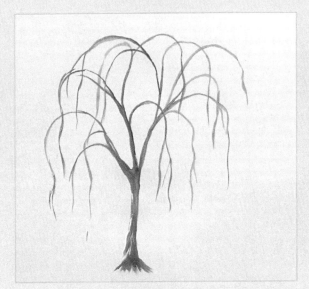

1. Paint the trunk and branches with Burnt Umber and Wicker White double loaded on a no. 10 flat. Stay on the chisel edge to create the softly curving, thin branches at the top and outer edges.

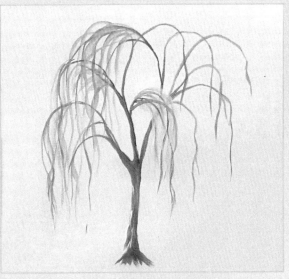

2. Double load a no. 10 flat with Hauser Green Medium and Yellow Citron and begin painting the weeping branches with long strokes that start at the branch and go up and over, then hang straight down. Start at the bottom of the tree and work upward.

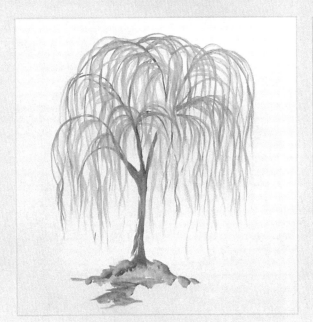

3. Fill out the rest of the branches, working upward and outward. Tap in foliage at the base of the tree with the same greens.

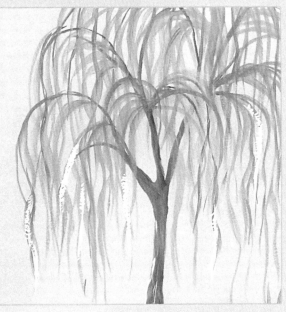

4. Tap on some tiny white flowers along the tips of some of the branches using Wicker White and the chisel edge of a no. 6 flat.

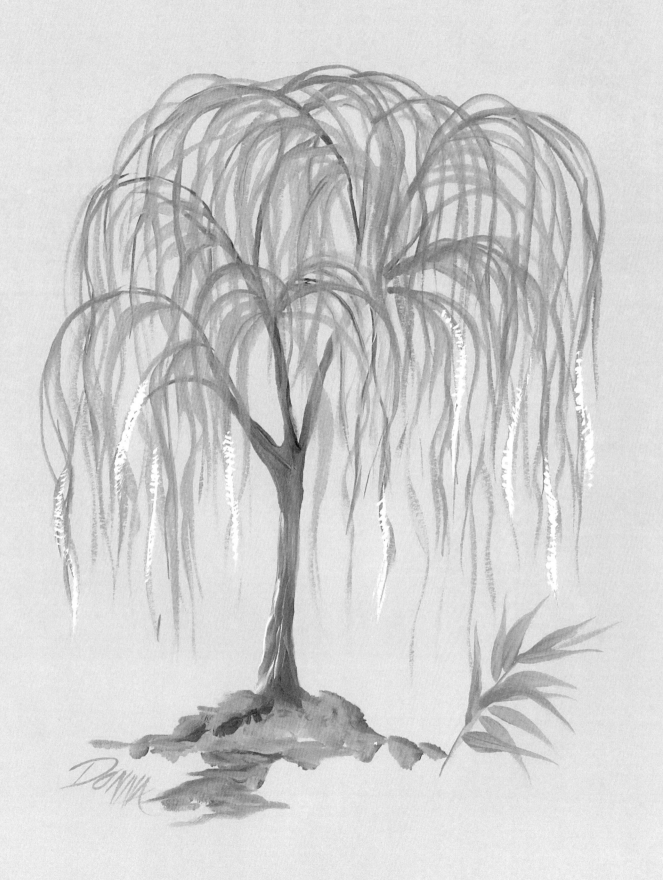

Evergreen

BRUSHES

no. 10 flat
no. 12 flat

COLORS

Burnt Umber Wicker White Thicket Yellow Citron

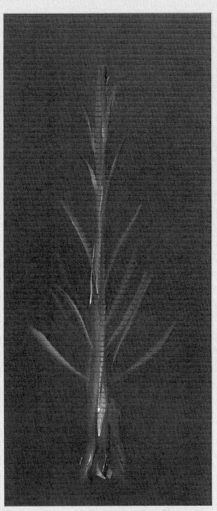
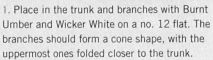

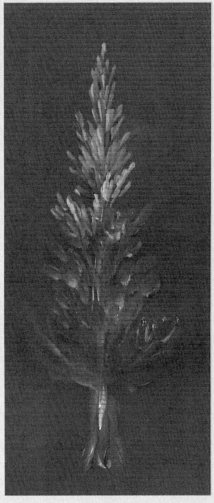

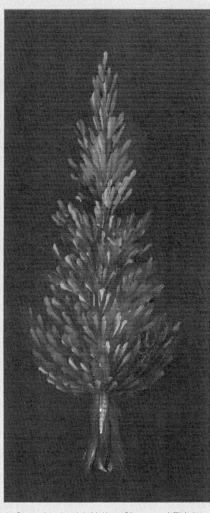

1. Place in the trunk and branches with Burnt Umber and Wicker White on a no. 12 flat. The branches should form a cone shape, with the uppermost ones folded closer to the trunk.

2. Begin the needle foliage at the very top of the tree using the chisel edge of a no. 10 flat double loaded with Thicket and Yellow Citron. As you get further down the trunk, use the Thicket to indicate the basic shapes of the lower branches.

3. Come back with Yellow Citron and Thicket on the brush and detail the needles on the lower branches with short chisel-edge strokes. To finish, use the same colors to tap in some foliage at the base of the tree. The closeup detail of a branch and needles is painted with the same colors as the tree.

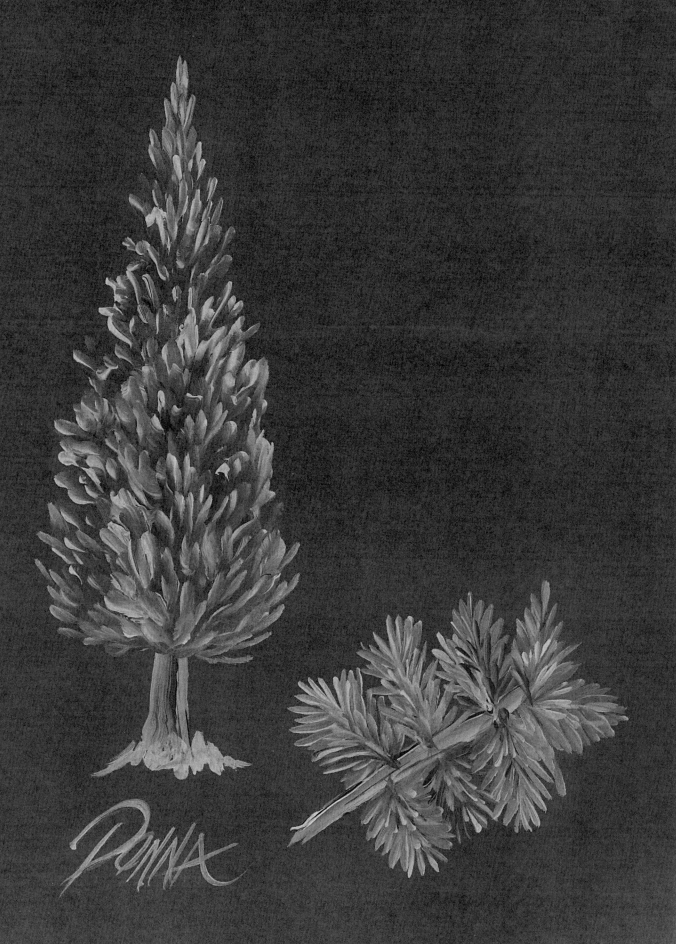

Flowering Apple Tree

COLORS

Burnt Umber Burnt Sienna Butter Pecan Wicker White Hauser Green Medium Thicket Sunflower Rose Pink Yellow Citron

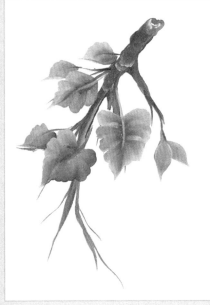

1. Paint the gnarled branches and twigs of the apple tree with Burnt Umber and Burnt Sienna on a no. 12 flat. The broken end is Butter Pecan and Wicker White.

2. The leaves are painted with Hauser Green Medium and Thicket, plus a little Sunflower. Most of the leaves have very ruffly, segmented edges. Some edges have a pink tint to them—this is a little bit of the Rose Pink on the lighter green corner of the brush.

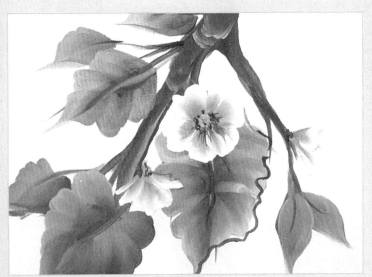

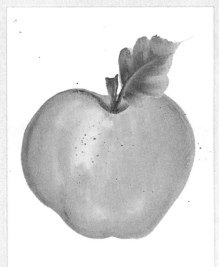

3. Begin the apple blossoms with a double load of Rose Pink and Wicker White on a no. 10 flat. Paint the open blossoms with a ruffled-edge stroke. The centers are tapped on with Thicket and Yellow Citron on a small scruffy. Outline the bottom edge of some leaves with inky Burnt Umber and a no. 2 script liner.

4. The ripening apple is painted with Yellow Light and Pure Orange. The edges are shaded with Burnt Sienna and the stem indentation is a stroke of Burnt Umber. Finish the design with a light, all-over spattering of Butter Pecan if you wish. Use an old toothbrush to keep the spatters very small and sparse.

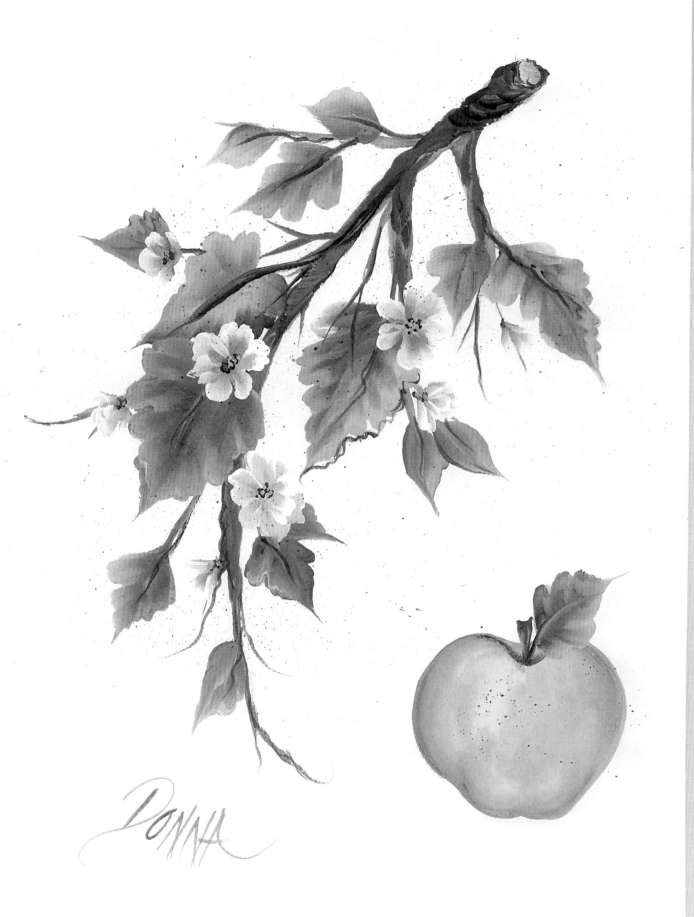

Italian Cypress

BRUSHES

no. 8 flat
no. 10 flat

COLORS

 Burnt Umber

Wicker White

 Hauser Green Medium

 Thicket

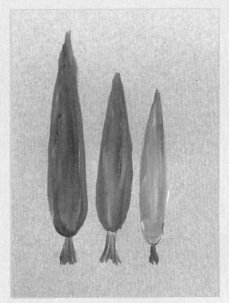

1. Place in the trunks of the trees with Burnt Umber and Wicker White. Double load a no. 10 flat with Hauser Green Medium and Thicket and basecoat the basic shapes of the trees. Turn your work upside down and pull your strokes toward you.

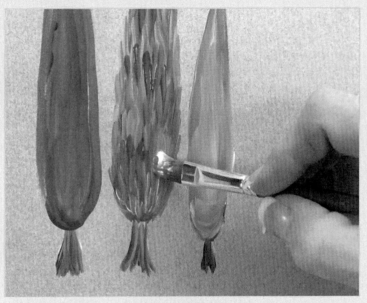

2. To detail the trees, use the same colors and brush to paint short vertical, downward strokes to form the vertical branches.

3. The needles of the cypress are painted with short downward motions of the brush. Paint some small twigs first for placement, then begin the needles at the outer tip.

4. Fill in with more needles, following the direction of the twigs. Use the same greens and tap some foliage around the base of the tree trunks to ground them.

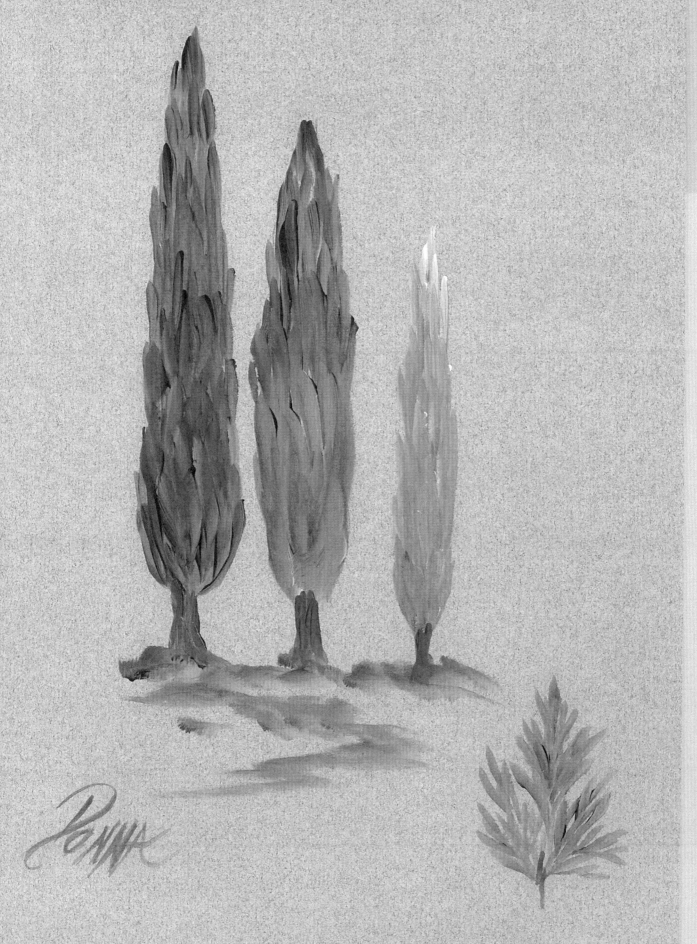

Palm Tree

BRUSHES

no. 10 flat

COLORS

Butter Pecan Wicker White Yellow Citron Thicket Burnt Umber

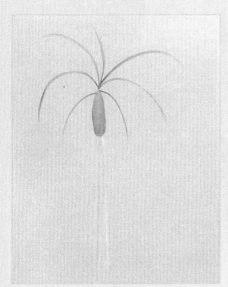

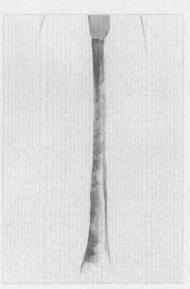

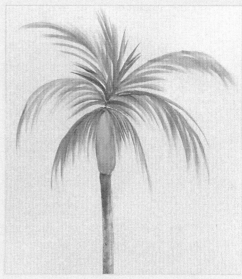

1. Place in the trunk with Butter Pecan and Wicker White on a no. 10 flat. The green part at the top where the trunk bulges out is Yellow Citron with a touch of Thicket. Draw the main stems of the palm fronds with a double load of Yellow Citron with a touch of Thicket.

2. Add texture and shading to the trunk with Burnt Umber. Touch the chisel edge of the no. 10 flat to the left side of the trunk and drag it partway across.

3. Begin the back underneath half of the palm fronds with fine curving strokes of the no. 10 flat double loaded with Thicket and Yellow Citron. Start at the base of each main stem and work toward the outer tip, pulling the strokes outward.

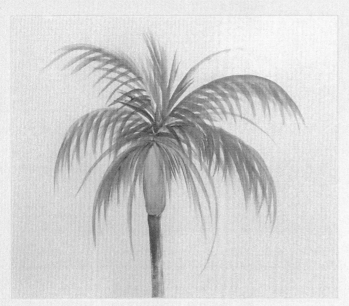

4. Change to a more downward angle and stroke the leaves that cross over in front of the underneath layer. Again, start at the base and work toward the tip. Don't crowd them—space them evenly along the stem.

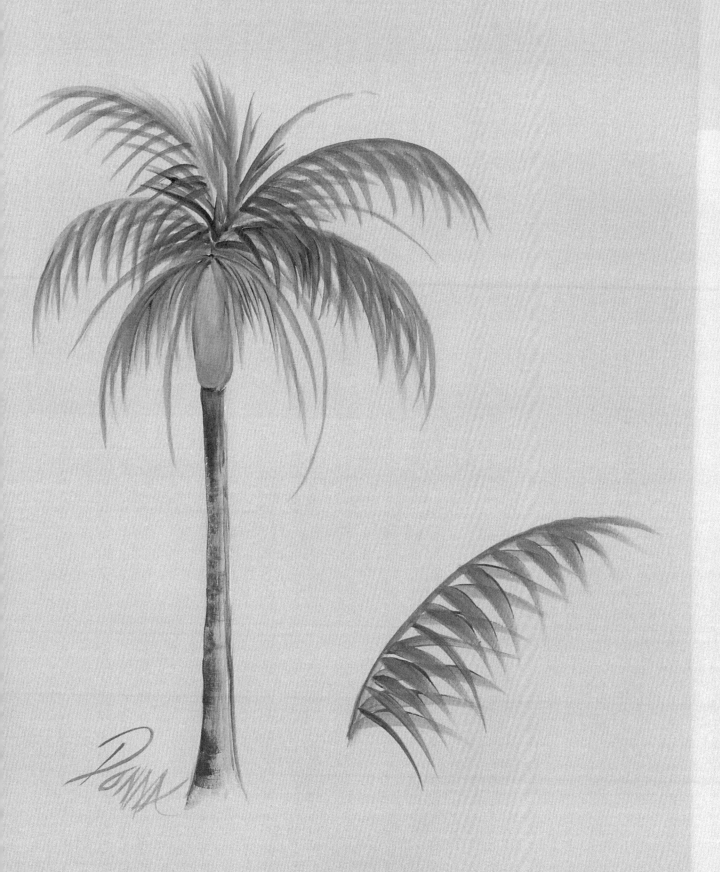

Long-Needle Pine Tree

BRUSHES

no. 8 flat
no. 10 flat
no. 2 script liner

COLORS

Burnt Umber Wicker White Yellow Citron Green Forest Thicket

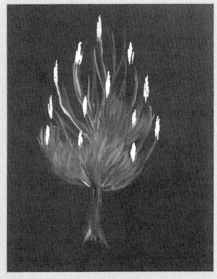

1. Paint the trunk and branches with Burnt Umber and Wicker White double loaded on a no. 10 flat.

2. Using Wicker White with a little Yellow Citron on the dirty brush, tap on the "candles" of new growth on the tips of the branches.

3. Double load Green Forest and Yellow Citron and begin stroking in the branches of green needles, using upward strokes with very light pressure on the chisel edge. Shade the needle clusters with Thicket coming up from the base where they attach to the branches.

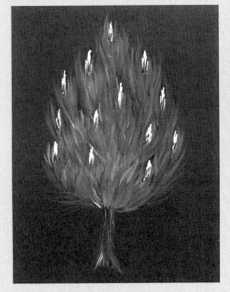

4. Continue building the needle foliage but make sure you can still see some branches through it. Shade the candles with taps of Burnt Umber on a no. 2 script liner.

5. For the needle detail, use a no. 8 flat to place in the main stem and to tap on the candle. Switch to a no. 2 script liner and pull each individual needle starting at the stem and pulling outward in a slight curve.

Pink Cherry Tree

BRUSHES

no. 8 flat
no. 10 flat
no. 12 flat
no. 2 script liner

COLORS

Burnt Umber Wicker White Magenta Thicket Yellow Citron Sunflower

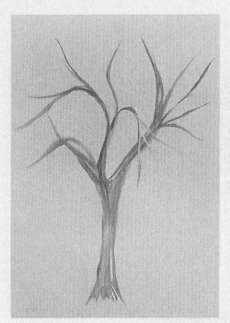

1. Double load Burnt Umber and Wicker White on a no. 12 flat and draw in the main trunk and the largest branches first. Then paint the smaller branches with curving lines.

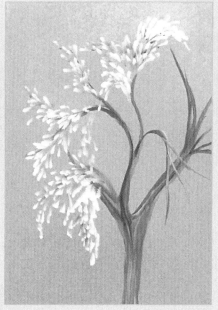

2. Double load a no. 8 flat with Magenta and Wicker White and begin tapping on the cherry blossoms using very light pressure on the chisel edge.

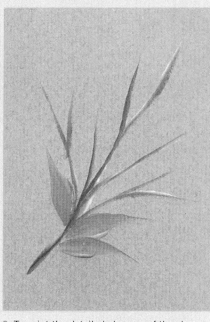

3. To paint the detailed close-up of the cherry blossoms, begin with twigs of Burnt Umber and Wicker White, then add a few leaves of Thicket and Yellow Citron.

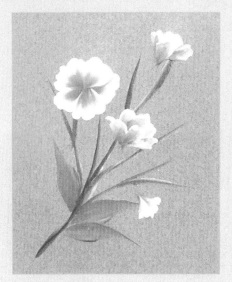

4. The blossoms are Magenta and Wicker White double loaded on a no. 10 flat. Use a ruffled five-petal flower stroke.

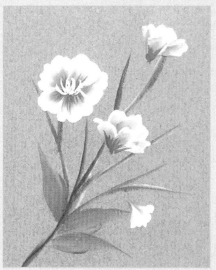

5. Darken the center with tiny lines of inky Magenta on a no. 2 script liner. Add stamens with inky Wicker White on a script liner, pulling upward from the center.

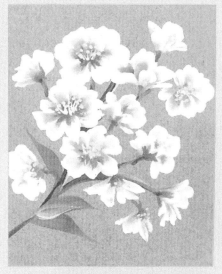

6. Use Sunflower on the tip of a no. 2 script liner and tap on the pollen dots.

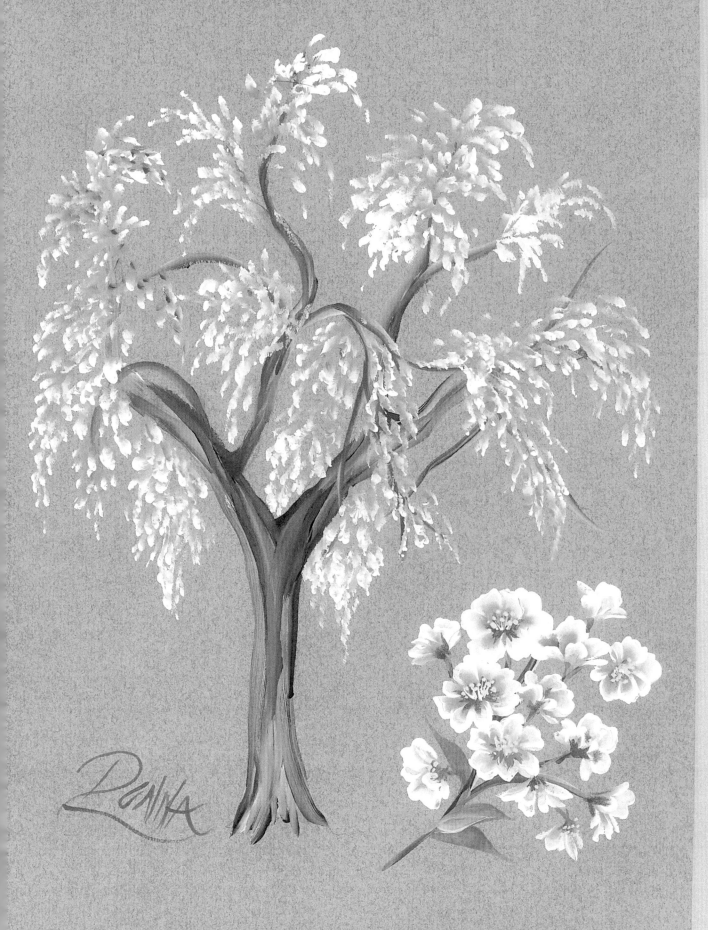

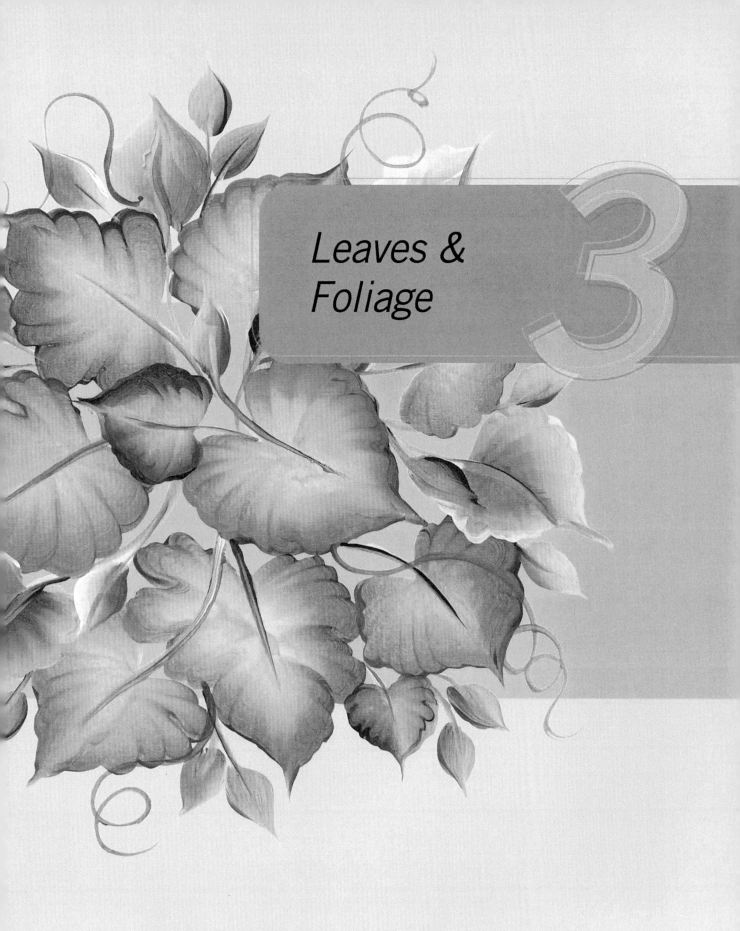

Leaves & Foliage

3

One-Stroke Leaves & Slider Leaves

BRUSHES

no. 6 flat
no. 8 flat
no. 10 flat

COLORS

Thicket Yellow Citron Purple Lilac Wicker White

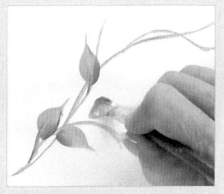

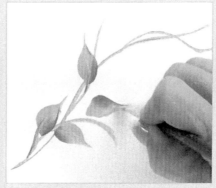

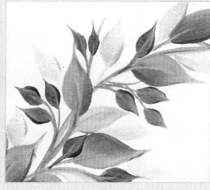

1. One-Stroke Leaves: Double load Thicket and Yellow Citron on a no. 10 flat. Place in the main vines with the chisel edge of the brush. Begin each one-stroke leaf by placing the chisel edge where the base of the leaf will be. Press down on the brush to form the wide part of the leaf.

2. Turn the brush and lift back up to the chisel edge to form the tip of the leaf. Pull a stem partway into the leaf using the chisel edge and very light pressure. This stem should begin at the main vine and curve into the leaf.

3. The smaller, darker leaves are painted with a no. 6 flat and Thicket. The shadow leaves in the background are painted with a no. 8 flat dressed in lots of Floating Medium and a little Thicket, or a little Purple Lilac for color variation.

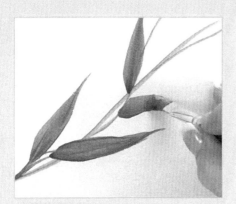

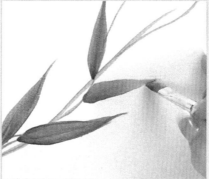

1. Slider Leaves: I call these "slider leaves" because they're made by sliding the brush straight out from the base to the tip. Double load a no. 10 flat with Thicket and Yellow Citron and place in the main vines with the chisel edge. Begin pulling the leaf starting at the base and widening out at the middle.

2. Continue pulling the leaf straight out, releasing pressure on the brush and lifting to the chisel edge at the tip. Pull a stem from the main vine into the leaf to connect them.

3. Vary the leaf colors by using Yellow Citron for the yellow leaves, and pick up a little Wicker White on the dirty brush for the lightest leaves.

Ruffled-Edge Leaves

BRUSHES
no. 8 flat
no. 16 flat

COLORS

Thicket

Yellow Citron

Wicker White

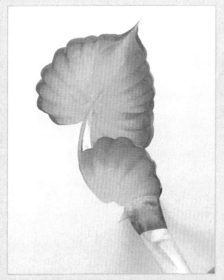

1. Load Thicket and Yellow Citron on a no. 16 flat. Begin the ruffled edge leaf at the top of the first half. Paint a shell stroke and pause.

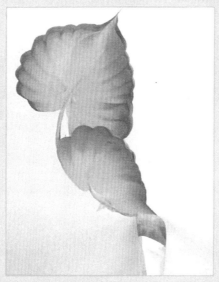

2. Now slide and lift to the chisel to the tip.

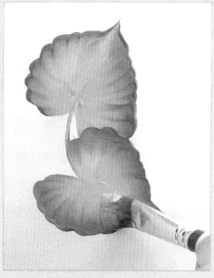

3. Start at the top of the other half and paint a shell stroke and pause.

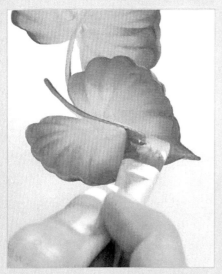

4. Then lift to the chisel and pull to the tip. Pull stems only partway into the centers of the leaves, not all the way to the tip.

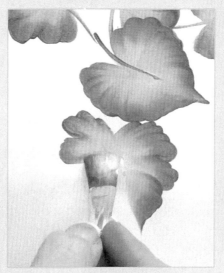

5. For a deeply lobed leaf, wiggle out, then slide back in more than you did on the ruffled edge leaf.

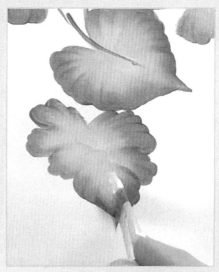

6. Wiggle back out, and slide back in to make as many lobes as you need. Finish with a ruffled edge, then lift to the chisel to form the tip of the leaf. Fill in the design with smaller leaves using a no. 8 flat. Pick up Wicker White on the double-loaded brush for color variations on some of the leaves.

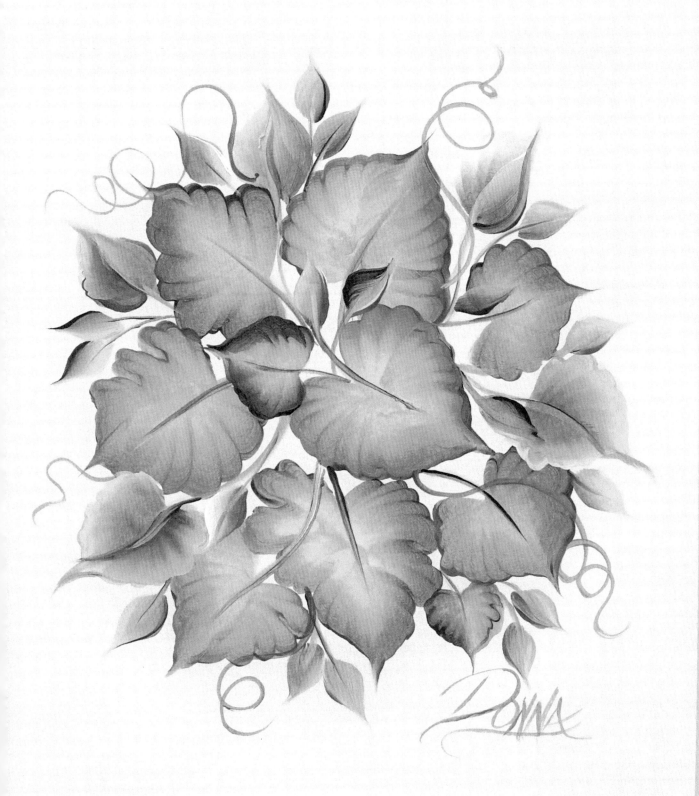

Rolled-Edge Leaves

BRUSHES

no. 10 flat
no. 16 flat

COLORS

Burnt Umber Burnt Sienna Wicker White Thicket Yellow Citron

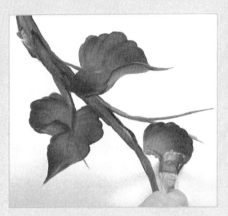 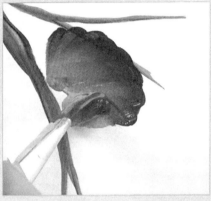 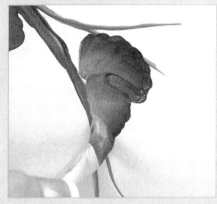

1. Place in the main branch and twigs with Burnt Umber and Burnt Sienna, plus a little Wicker White, on a no. 16 flat. Multi-load a no. 16 flat with Burnt Sienna, Thicket and Yellow Citron and begin the rolled-edge leaf with a shell stroke for the top part of one half of the leaf. Keep the dark green side of the brush to the outside edge of the leaf.

2. To roll the edge, pivot the brush to bring the dark green side up and over towards the center.

3. Lay the brush flat again and wiggle down to the tip. Be sure the dark green side of the brush is still to the outside edge of the leaf.

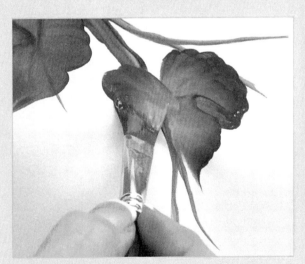 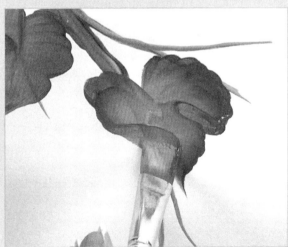

4. Go back to the top and begin the other half of the leaf. Turn your brush over so the darker green side is to the outside edge of the leaf. Start with a shell stroke.

5. To roll the edge, pivot the brush to bring the dark green side up and over towards the center, then slide to the tip without lifting your brush off the paper. Fill in your leaf design with more rolled-edge leaves using the same colors. Pick up some Wicker White on the dirty brush for the smaller, newer leaves where the backs are visible.

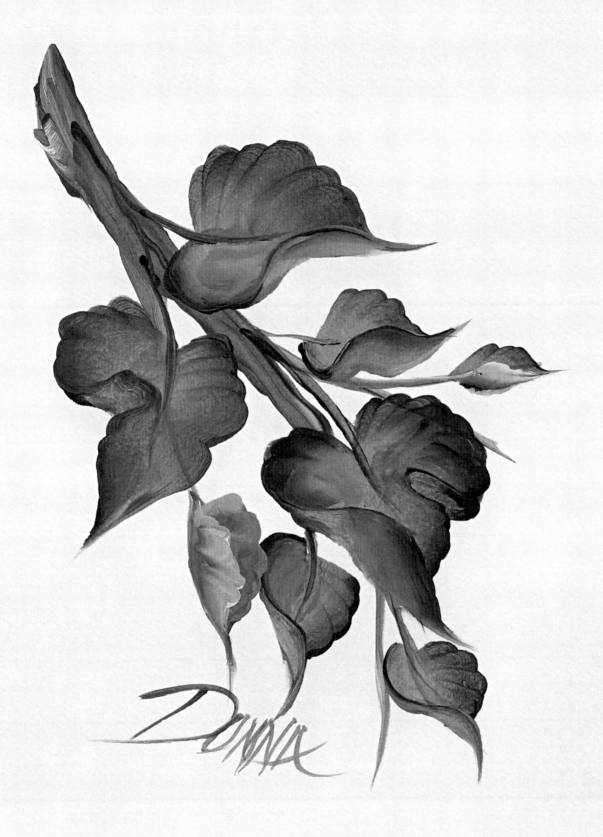

Grape Leaves

BRUSHES

no. 8 flat
no. 16 flat
no. 2 script liner

COLORS

Thicket Yellow Citron Yellow Light Wicker White

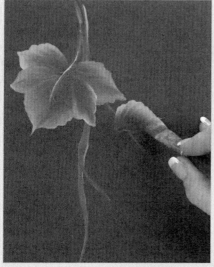

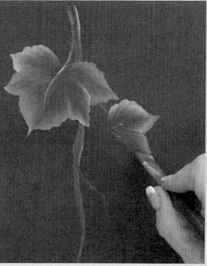

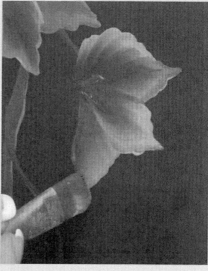

1. Place the main grapevine with Thicket and Yellow Citron on a no. 16 flat. Begin the leaf with the lobe that's closest to the stem. Hold the brush so the Yellow Citron side is to the outside edge of the leaf. Wiggle out to the point of the first lobe.

2. Slide in toward the middle of the leaf, then wiggle out again to the point of the next, smaller lobe.

3. Slide back in again, then wiggle straight down to form the bottom, pointed-tip lobe.

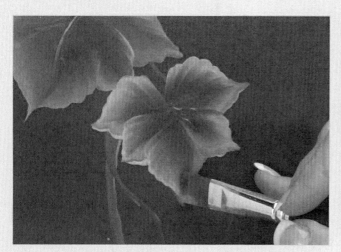

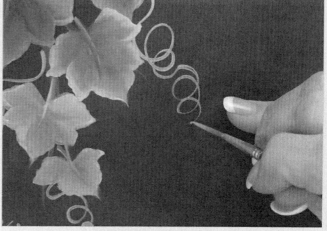

4. Paint the second half of the leaf the same way, starting at the top lobe and working down in sections, ending at the pointed tip. Be sure the Yellow Citron side of the brush is to the outside edge of the leaf.

5. As the leaves get smaller and younger, pick up more Yellow Light and Wicker White on a no. 8 flat that's been loaded with Yellow Citron. On a no. 2 script liner, load Thicket and Yellow Citron, pick up some Wicker White and paint the tightly coiled grapevine tendrils using small circular motions.

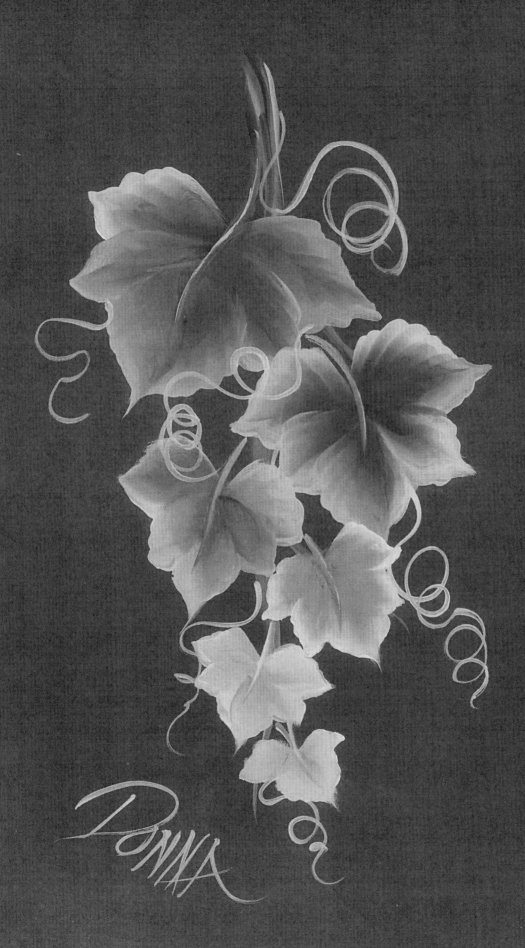

Grasses & Vines

BRUSHES

no. 12 flat
no. 2 script liner

COLORS

Thicket Yellow Light Yellow Citron

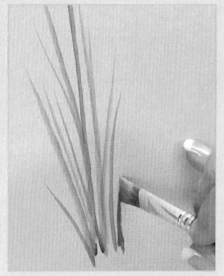

1. Double load a no. 12 flat with Thicket and Yellow Light and pick up Floating Medium. Start at the base of the grass blades and lead with the yellow side of the brush as you stroke upward to create the darker green blades.

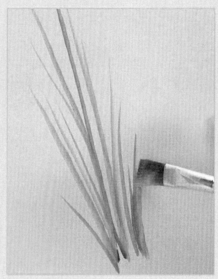

2. Flip the brush over so the green side is leading upward to create the lighter colored grass blades. Whatever color is following is the dominant color that you will see on the grass.

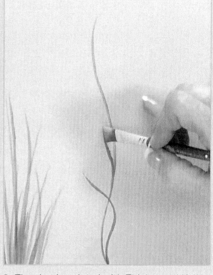

3. The vine is painted with Thicket and Yellow Citron on a no. 12 flat. Begin at the bottom and chisel edge a curving line upward. The smaller vines begin at the main vine, curve away from the main vine, then cross over it.

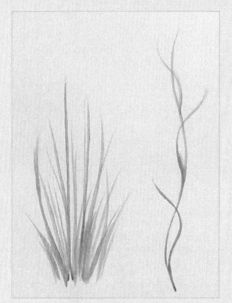

4. Leading with the Yellow Citron side of the brush will give you the darker green vines.

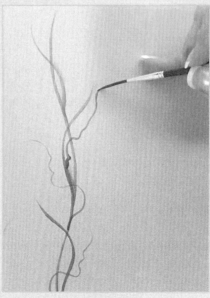

5. The tendrils are painted with inky Thicket on a no. 2 script liner.

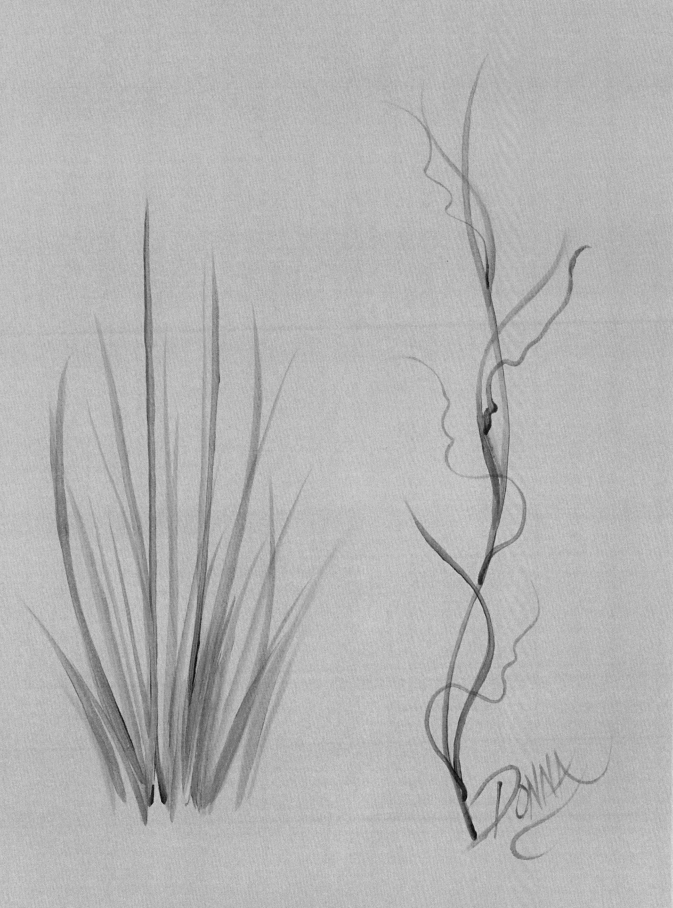

Ferns

BRUSHES

no. 6 flat
no. 8 flat
no. 12 flat
no. 2 script liner

COLORS

Thicket Wicker White Yellow Citron Yellow Light

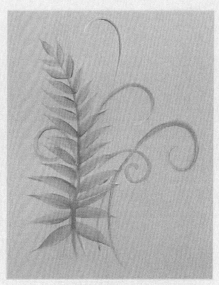

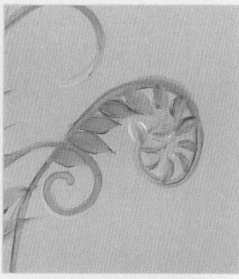

1. On a no. 12 flat, double load Thicket and Wicker White and place in the main stems. For the curled stems, use a no. 2 script liner, start at the tip of the curl and stroke in a circle toward the stem.

2. On a no. 8 flat, double load Thicket and Yellow Citron and begin painting the fern leaves by pressing down and sliding out sideways away from the stem. The leaves are in pairs along the stem. Add another curled stem for an unfurling frond (see step 3).

3. To paint the fresh new leaves that are unfurling, pick up more Yellow Citron on a no. 6 flat along with some Thicket and a tiny bit of Wicker White. As you paint leaves down the stems, pick up more Thicket on your brush because these are older, darker leaves.

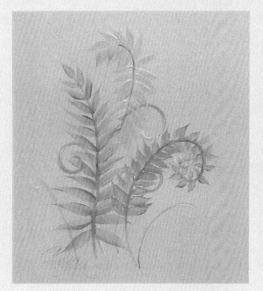

4. For the lighter green fern, use Yellow Citron and pick up a little Yellow Light plus some Floating Medium on a no. 8 flat. Don't add too many leaves or the airy look of the ferns will disappear.

5. If you wish, add a little yellow butterfly using Yellow Light and Wicker White for the wings, Thicket for the body, Yellow Light for the antennae tips and Yellow Citron for the body segments.

Hosta

COLORS

Thicket Yellow Citron Wicker White Magenta Yellow Light Fresh Foliage Basil Green

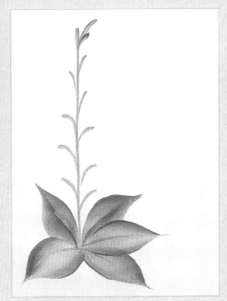

1. Double load a no. 12 flat with Thicket and Yellow Citron. Place in the stem and large base leaves. Pick up Wicker White for a couple of the leaves instead of Yellow Citron.

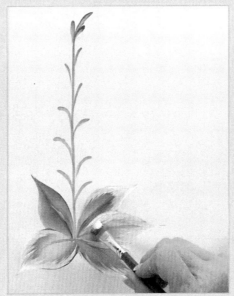

2. With Wicker White on the dirty brush, add white variegation to the leaf edges by outlining the leaf edge, then pulling feathery chisel edge strokes toward the base of the leaf.

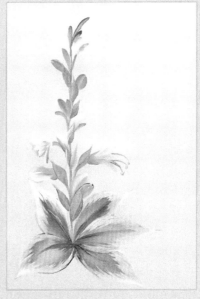

3. Double load Magenta and Wicker White and paint the hosta flowers. Pull green stamens out of the open flower, dot with Yellow Light for pollen. Pull some small green leaves over the buds.

4. Here's a variation on the hosta leaf: white centers with green edges. Paint the leaf shape with Wicker White. Load Thicket and pull a fine green stem partway into the leaf.

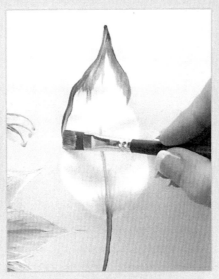

5. Outline the leaf edge with a double load of Thicket and Fresh Foliage and pull fine streaks down toward the base. With Basil Green and a no. 2 script liner, draw fine pleat lines in the leaf.

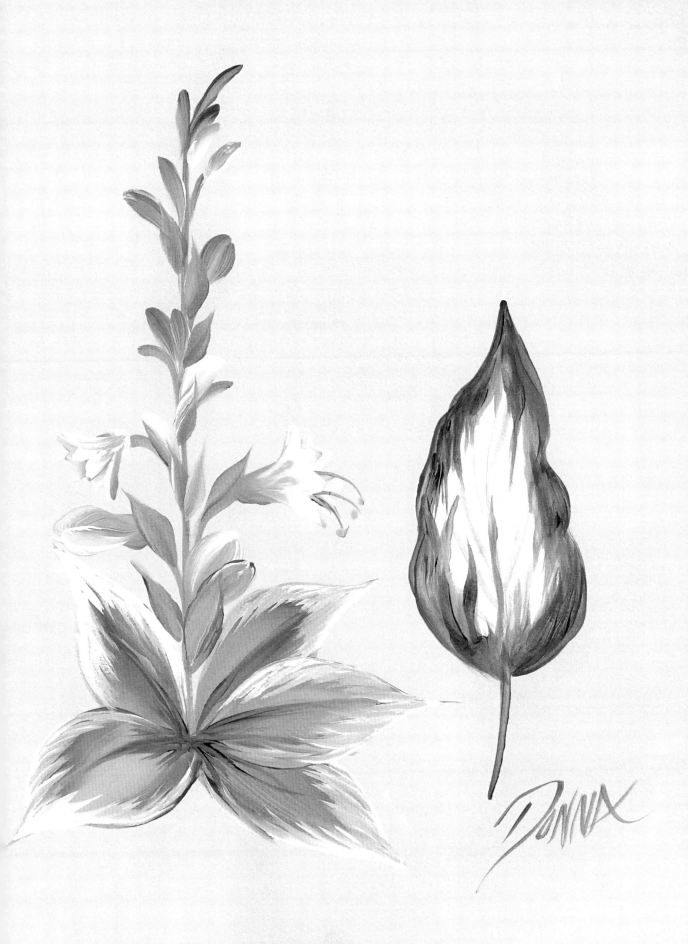

Bamboo

BRUSHES

no. 6 flat
no. 10 flat

COLORS

 Burnt Sienna Sunflower Yellow Citron Thicket

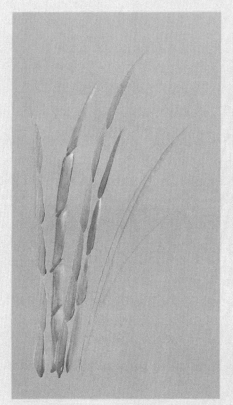

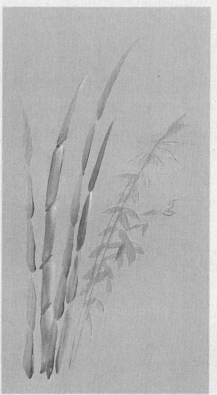

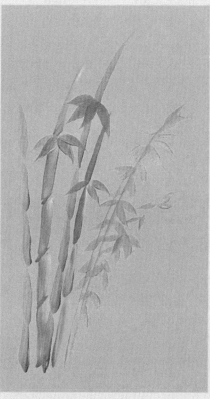

1. Double load Burnt Sienna and Sunflower on a no. 10 flat and place in the brown canes with stop and start motions of the brush to indicate the growth segments of the canes. The green canes are Yellow Citron and Thicket, plus some Floating Medium, on the same brush. Add a few faint shadow canes for the background by stroking upward on the chisel edge.

2. Use a no. 6 flat dressed with Floating Medium and double loaded with Thicket and Yellow Citron to paint the lighter bamboo leaves in the background.

3. Double load Thicket and Yellow Citron (no Floating Medium this time) and paint the long slender bamboo leaves of the mature canes. The leaves are attached to the canes where the growth segments are, but for more interest, don't cover up every growth segment— allow plenty of open space along the canes.

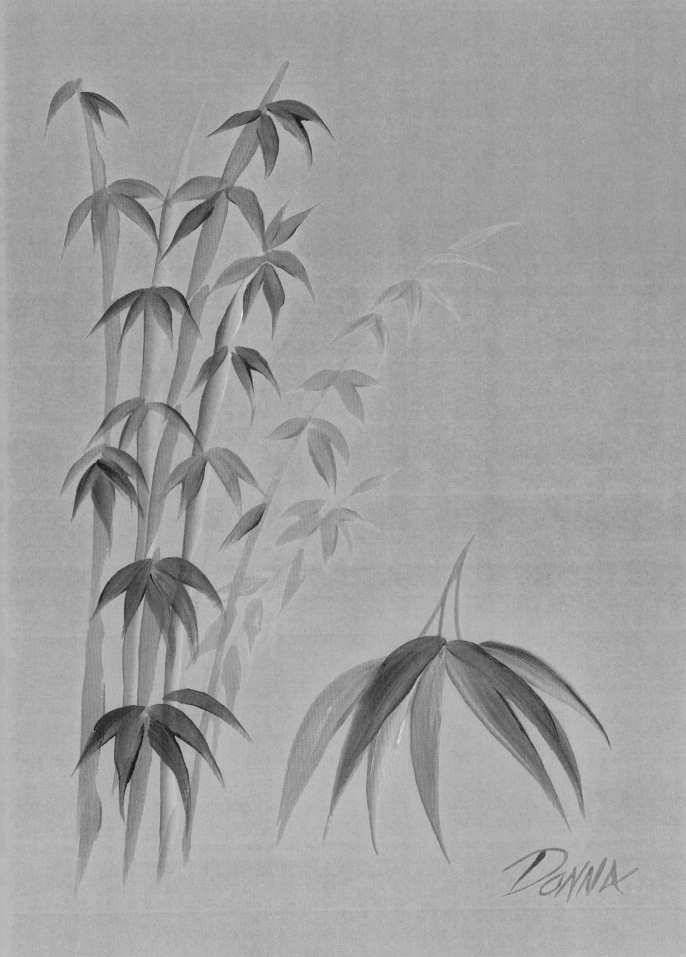

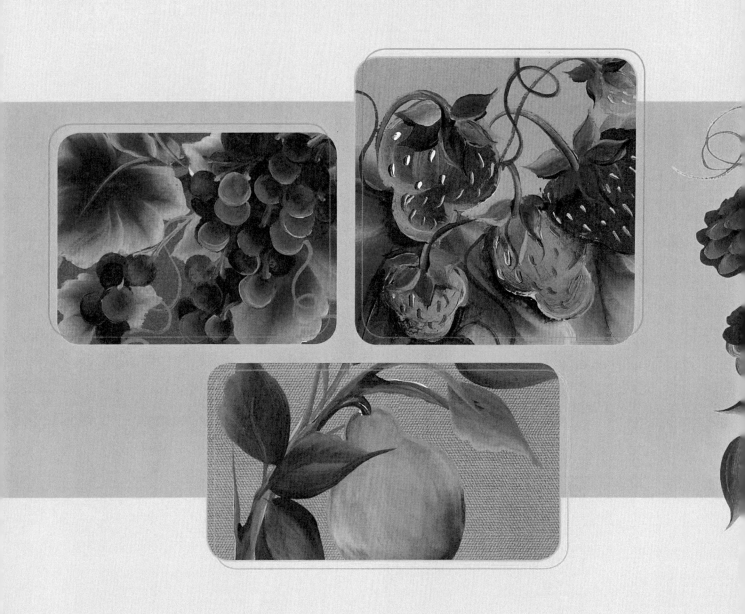

Fruits & Berries

4

Cherries & Strawberries

BRUSHES

no. 2 flat
no. 6 flat
no. 12 flat
no. 16 flat
no. 2 script liner

COLORS

 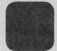

Burnt Umber Thicket Yellow Light Green Forest Wicker White Engine Red True Burgundy Yellow Citron

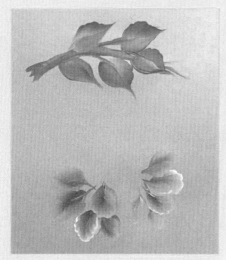

1. Cherries: Double load a no. 16 flat with Burnt Umber and Thicket plus a little Yellow Light and paint the cherry tree branch (top). The leaves are painted with Thicket, plus a little Green Forest and Yellow Light. The strawberry leaves (bottom) are Thicket, Yellow Light and Wicker White. Turn your brush so the white side is to the outside edges on some of these leaves.

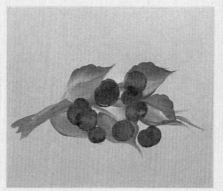

2. Begin the cherries with a no. 12 flat and Engine Red with a little Yellow Light. You may need to pick up some Wicker White to help get coverage because both the red and yellow are transparent colors. To shade one side of the cherries, pick up True Burgundy on the red side of the brush.

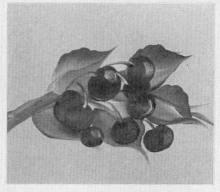

3. Pick up Green Forest and Yellow Light on a no. 2 script liner and pull stems from the cherries to the main branch. Highlight most of the cherries with a single stroke of thinned Yellow Light. Where the stem attaches to the cherry, paint the indentation with a sideload float of Burnt Umber, and shade around each cherry to separate it from the next one and to show roundness.

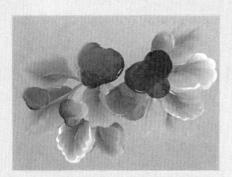

1. Strawberries: Base in the strawberries with mostly Yellow Light and some Engine Red. Make some of the smaller strawberries look less ripe by picking up more yellow on your brush.

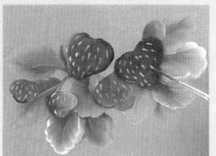

2. Separate the leaves and shade underneath the strawberries with a sideload float of Burnt Umber. Load a no. 2 script liner with Burnt Umber and streak through a little Wicker White. Pull short vertical lines to form the seeds, following the contour of each berry.

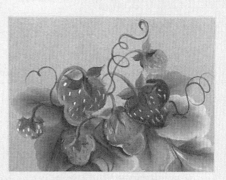

3. On a no. 6 flat, use Thicket and Yellow Light to paint the little leaves of the hulls and to pull the stems. Load a no. 2 script liner with inky Thicket and Yellow Light and paint the tendrils. Base in both blossoms with Wicker White and Yellow Citron. Shade the strawberry blossom's center with streaks of Burnt Umber and Wicker White on a no. 2 flat. The stamens for both are inky Green Forest on a script liner; the pollen dots are Wicker White and Yellow Light.

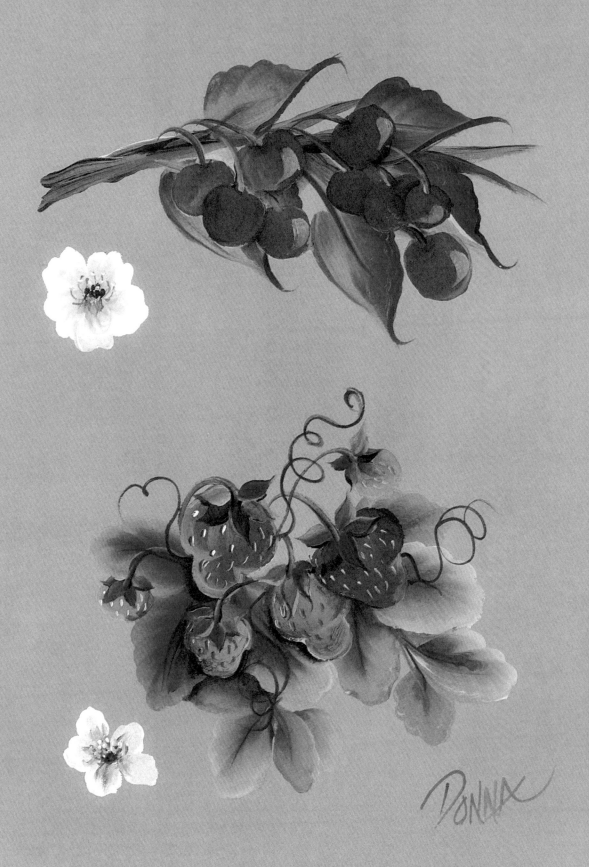

Blueberries

BRUSHES

no. 2 flat
no. 8 flat
no. 8 filbert
no. 2 script liner

COLORS

Burnt Umber

Wicker White

Thicket

Yellow Light

Brilliant Ultramarine

Night Sky

Licorice

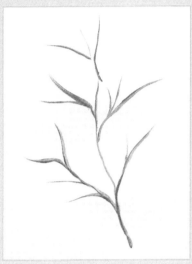

1. Begin with stems of Burnt Umber and Wicker White on a no. 2 script liner.

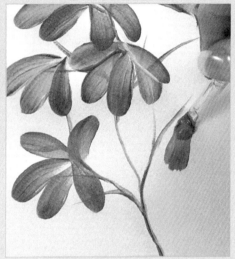

2. Double load a no. 8 filbert with Thicket and Yellow Light and begin painting the leaves. Place the rounded end of the filbert brush at the outer tip of the leaf, press down and pull toward you with a slight curve.

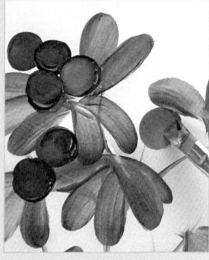

3. Switch to a no. 8 flat and load into Brilliant Ultramarine. Pick up a little Wicker White to lighten this intense blue and paint each berry in two half-circle strokes.

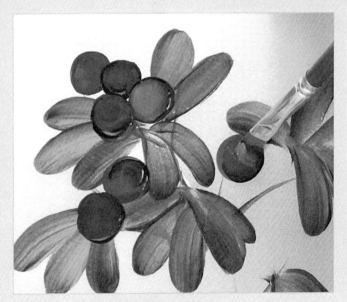

4. Pick up Night Sky on one corner of the dirty brush to shade the bottom half of each berry and to show that it's rounded.

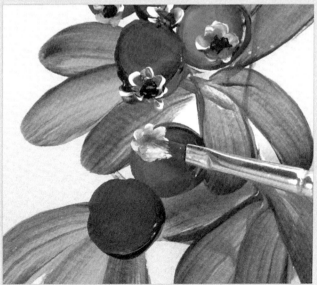

5. The blossom ends are dotted on with a double load of Brilliant Ultramarine and Wicker White on a no. 2 flat. Darken the center of the blossom end with Licorice on a no. 2 script liner.

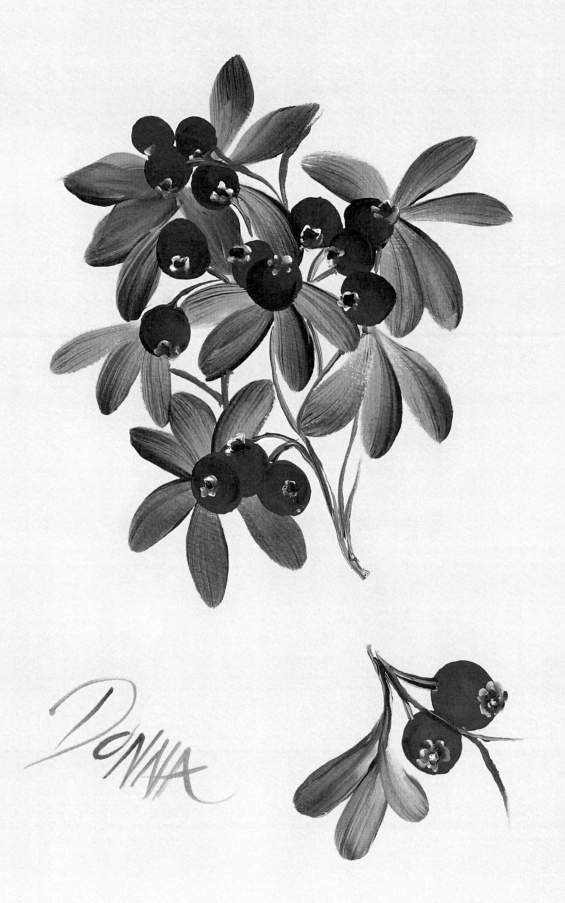

Donna

Pear

BRUSHES

no. 10 flat, no. 16 flat, 3/4-inch (19mm) flat, 1/4-inch (6mm) scruffy, and a no. 2 script liner.

COLORS

| Burnt Umber | Wicker White | Yellow Light | Yellow Ochre | Engine Red | True Burgundy | Yellow Citron | Hauser Green Medium | Magenta | Thicket |

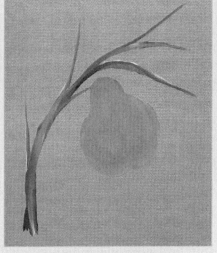

1. With a no. 16 flat, place in the pear tree branch with Burnt Umber and Wicker White. Using the same dirty brush, basecoat the pear using Yellow Ochre and Yellow Light.

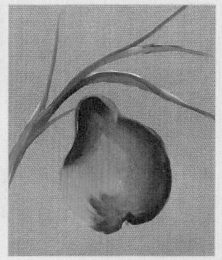

2. Pick up Engine Red and some True Burgundy on the same dirty brush and paint the ripening parts of the pear.

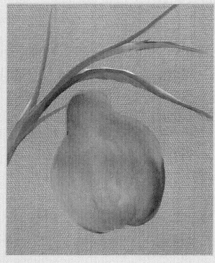

3. Pick up Yellow Light and Yellow Citron on the dirty brush and fill in the center area, toning down the red, but letting it show through as streaks of color.

4. Switch to a no. 10 flat and load it with Hauser Green Medium and a little Floating Medium. Paint the light green areas on the pear using curving strokes to follow the shape. Warm up the green with more Yellow Citron here and there. Paint the stem and blossom end with Burnt Umber and Wicker White.

5. Paint the leaves with a 3/4-inch (19mm) flat double loaded with Yellow Citron and Thicket, plus a little Burnt Umber for depth. For the darker leaves, pick up more Burnt Umber on the brush.

6. The pear blossom is painted with little stems of Burnt Umber and Wicker White on a no. 2 script liner. Double load Thicket and Yellow Light, plus a little Burnt Umber on a no. 10 flat and paint a small leaf. The blossom is painted with Wicker White and a little Magenta. Pounce on the center with Burnt Umber and Yellow Ochre on a 1/4-inch (6mm) scruffy. With a script liner, pull stamens of inky Burnt Umber and tap on pollen dots of Yellow Light and Wicker White. Shade the center with little dots of Burnt Umber.

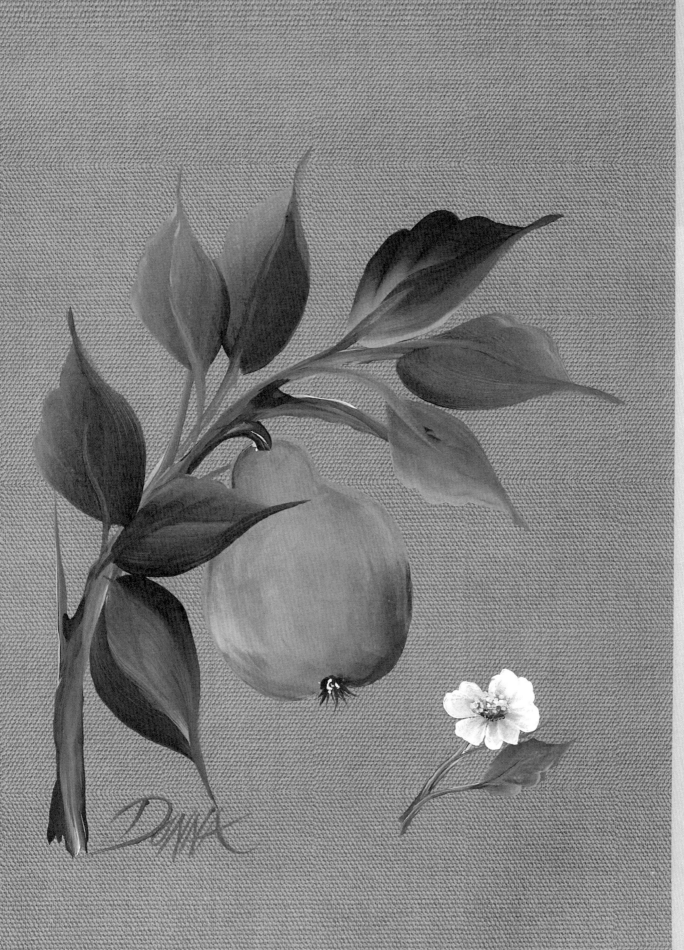

Apple

BRUSHES

no. 10 flat
no. 16 flat
3/4-inch (19mm) flat
1/4-inch (6mm) scruffy
no. 2 script liner

COLORS

Burnt Umber Wicker White Thicket Yellow Light Green Forest School Bus Yellow Engine Red True Burgundy

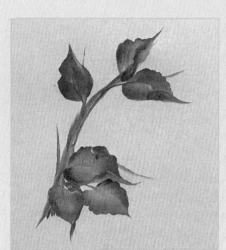

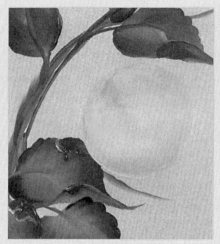

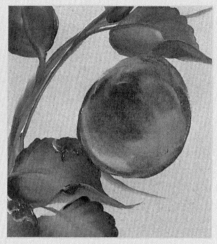

1. With Burnt Umber and Wicker White on a no. 16 flat, paint the branch and twigs. The leaves are Thicket and Yellow Light; pick up a little Green Forest sometimes to darken the green. Some of the leaf edges are dark brown and curled as if they are dried up. Use Burnt Umber for these, then go back with a little Wicker White on a no. 2 script liner and outline them along the top edge.

2. Basecoat the apple with a double load of Yellow Light and School Bus Yellow on a 3/4-inch (19mm) flat.

3. Pick up Engine Red on your dirty brush and pull vertical strokes following the rounded shape of the apple. Don't cover up all the yellow basecoat.

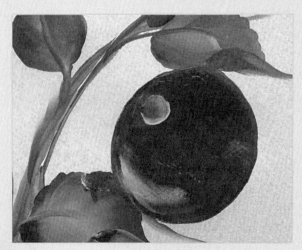

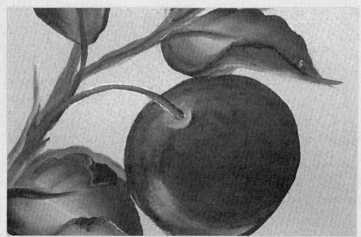

4. Darken the top edge of the apple with True Burgundy on the dirty brush. The indentation at the top where the stem attaches is indicated with School Bus Yellow on a no. 10 flat. Darken the apple color and shade with more True Burgundy.

5. Pull a stem into the indentation with Burnt Umber and Wicker White on a no. 10 flat. To paint the apple blossom, load the brush mostly with Wicker White and a little Burnt Umber and paint five wiggle-edge petals. Leave space between each petal. Pounce Burnt Umber in the center with a 1/4-inch (6mm) scruffy. Tap on Green Forest, Wicker White and Yellow Light pollen dots using the tip of a no. 2 script liner.

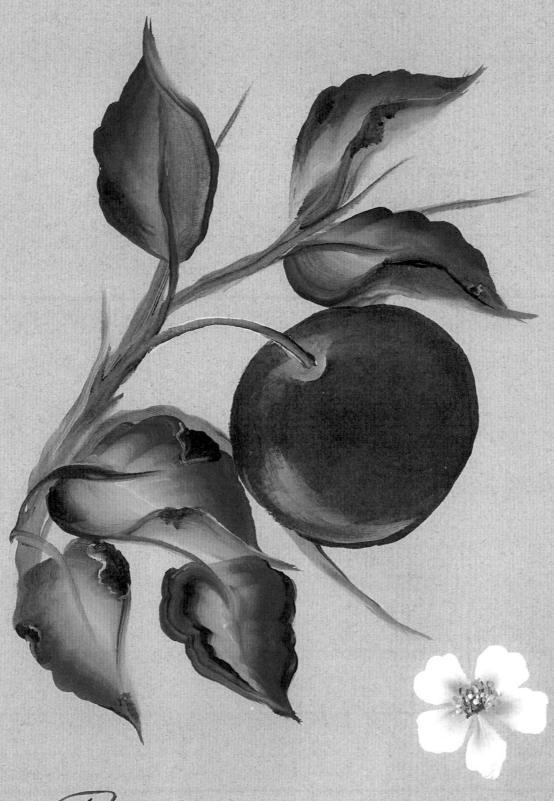

Grapes & Plums

BRUSHES

no. 8 flat
no. 16 flat
3/4-inch (19mm) flat
no. 2 script liner

COLORS

Thicket Yellow Light Green Forest Wicker White Burnt Umber Violet Pansy Night Sky

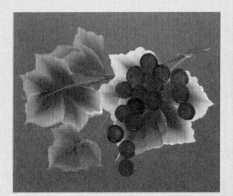

1. **Grapes:** Begin with the leaves. Double load a 3/4-inch (19mm) flat with Thicket and Yellow Light and pick up Green Forest on the Thicket side to darken. For a few of the leaves, pick up some Wicker White on the yellow side to lighten the edges and make them stand out against the green background. Some of the grape leaves have a touch of Burnt Umber in them for depth of color. Base in the grapes starting at the top and working down into the cluster. Double load Violet Pansy and Night Sky on a no. 8 flat, and paint each grape in two half-circle strokes, one upper and one lower.

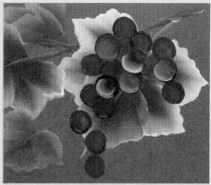

2. Highlight the lower half of the grapes with Wicker White on the dirty brush.

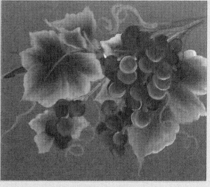

3. Tuck in some small green leaves here and there to fill out the design, and finish the grapes with some tendrils and stems using Thicket and Yellow Light on a no. 2 script liner.

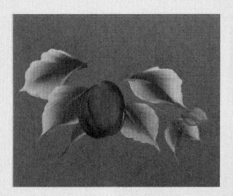

1. **Plums:** Begin with the leaves. Double load a 3/4-inch (19mm) flat with Thicket and Yellow Light and pick up Green Forest on the Thicket side to darken. For a few of the leaves, pick up Wicker White on the yellow side to lighten the edges. Base in the first plum with Violet Pansy and Night Sky on a no. 16 flat. Keep the Night Sky side to the outside edge of the plum.

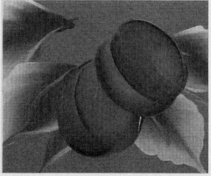

2. Paint the second plum overlapping part of the first.

3. Finish the plums with a cluster of leaves over the plums painted with the same greens used in step 1.

104

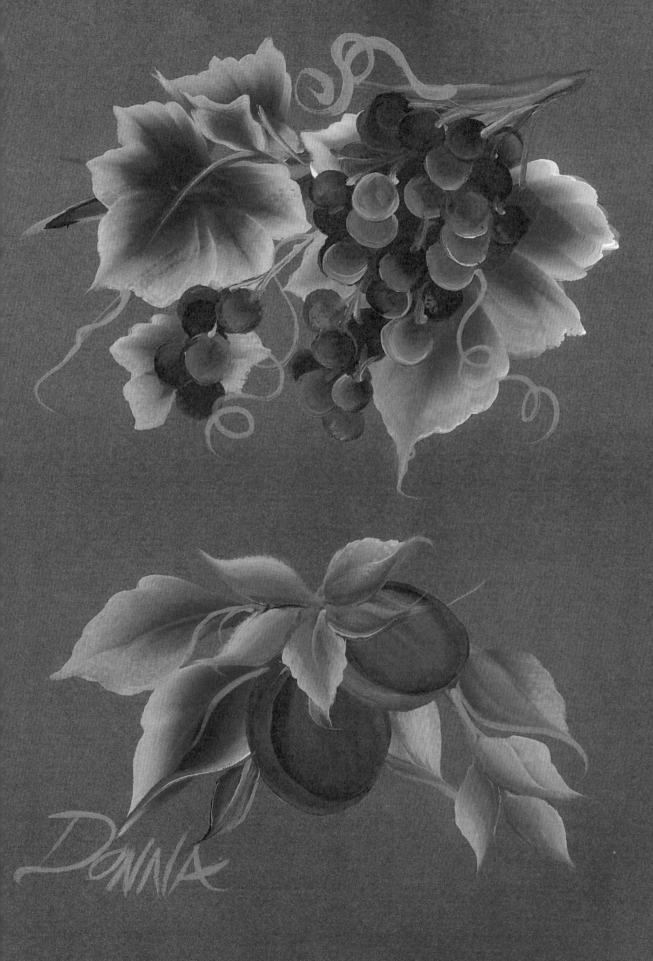

Oranges & Lemons

BRUSHES

no. 6 flat
no. 10 flat
no. 12 flat
no. 16 flat
3/4-inch (19mm) flat
3/4-inch (19mm) scruffy
no. 2 script liner

COLORS

Yellow Light	Pure Orange	Green Forest	Wicker White	School Bus Yellow	Yellow Ochre	Magenta

1. **Orange:** Load a 3/4-inch (19mm) flat with Yellow Light, pick up a little Pure Orange, and basecoat the round shape.

2. Double load Yellow Light and Pure Orange on the dirty brush and paint around the edges to shade and imply roundness. While the paint is wet, use a large scruffy with a little Wicker White on one corner and pounce in the wet paint to get the texture of the orange rind.

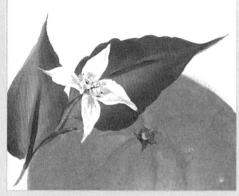

3. With a sideload float of Pure Orange on a no. 12 flat, paint the indentation lines where the stem was attached to the top of the orange. With a no. 2 script liner and Green Forest and Yellow Light, tap in the stem end and pull out five little points. The leaves are Green Forest and Yellow Light on a no. 16 flat. Paint the four petals of the blossom with Wicker White on a no. 6 flat. Add Green Forest stamens and pollen dots of Yellow Light and School Bus Yellow.

1. **Lemon:** Load a 3/4-inch (19mm) flat with Wicker White, Yellow Light and School Bus Yellow and basecoat the shape of the lemon. Keep the white side of the brush to the inside and the School Bus Yellow side to the outside to shade and shape the left edge.

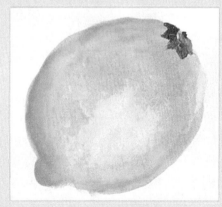

2. Pounce texture on the lemon with a scruffy using Yellow Light and Wicker White. Load a no. 10 flat with Floating Medium and sideload into Yellow Ochre. Shade around the outside edges to indicate roundness. With a no. 2 script liner and Green Forest and Yellow Light, tap in the stem end and pull out several little points.

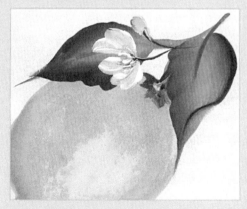

3. The leaves are Green Forest and Yellow Light on a no. 12 flat. To paint the blossom petals, use a no. 6 flat with Wicker White and a little Yellow Light. Come back with a little Magenta on the dirty brush and stroke some pink on the petals. Pull some tiny stems using Green Forest and Yellow Light on a no. 2 script liner.

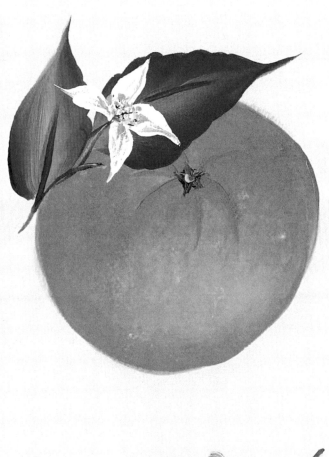

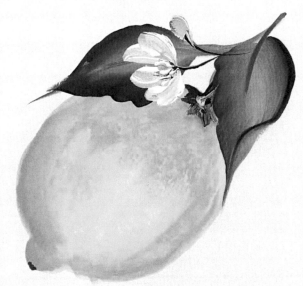

Blackberries

BRUSHES

no. 6 flat
no. 8 flat
no. 12 flat
no. 16 flat
no. 2 script liner

COLORS

Green Forest · Yellow Light · Berry Wine · Night Sky · Wicker White · Purple Lilac · Thicket · Yellow Citron

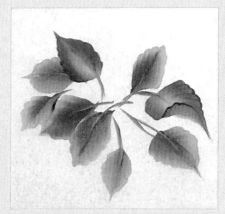

1. Place in the leaves with Green Forest and Yellow Light on a no. 16 flat. Pull stems into the leaves using the chisel edge of the flat brush.

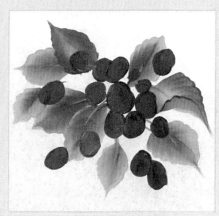

2. Using a no. 12 flat, basecoat the basic shape of each unripe berry with Berry Wine; for the riper, darker berries, pick up Night Sky on the dirty brush. Blackberries are not round, they're slighted elongated.

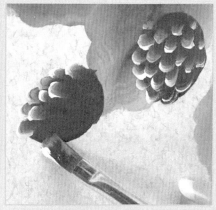

3. Load a no. 6 flat with Berry Wine and sidestroke into Wicker White. Paint the individual seed segments on the lighter, unripe berries. The outer segments should extend beyond the edges of the basecoated shapes. Each segment is a tiny U-stroke. Paint all the outside segments first, then build from the bottom up, like shingles on a roof.

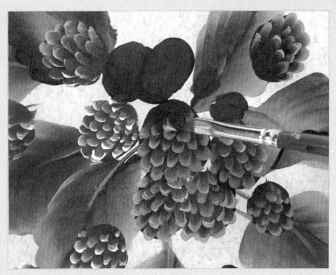

4. The segments on the darker, riper berries are painted the same way. Load a no. 6 flat with Night Sky and pick up Purple Lilac on one corner.

5. The calyxes and small one-stroke leaves are painted with Green Forest and Yellow Light on a no. 6 flat. The tendrils are inky Green Forest on a no. 2 liner. The blossom is painted with Wicker White and Floating Medium on a no. 8 flat. Load a no. 6 flat with Thicket, Wicker White and a little Yellow Citron and paint the five small leaves between each petal. Use inky Green Forest for the stamens, and Yellow Light and a little Wicker White for the pollen dots.

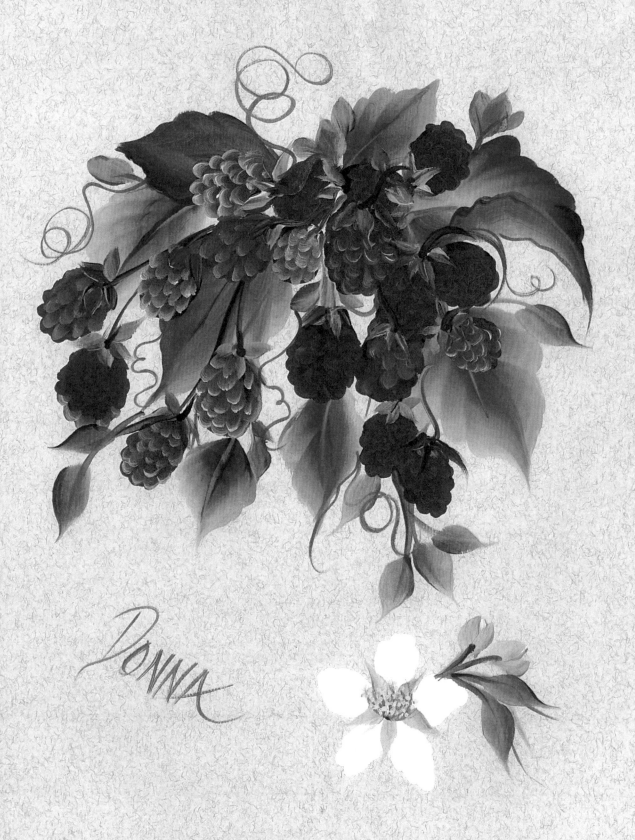

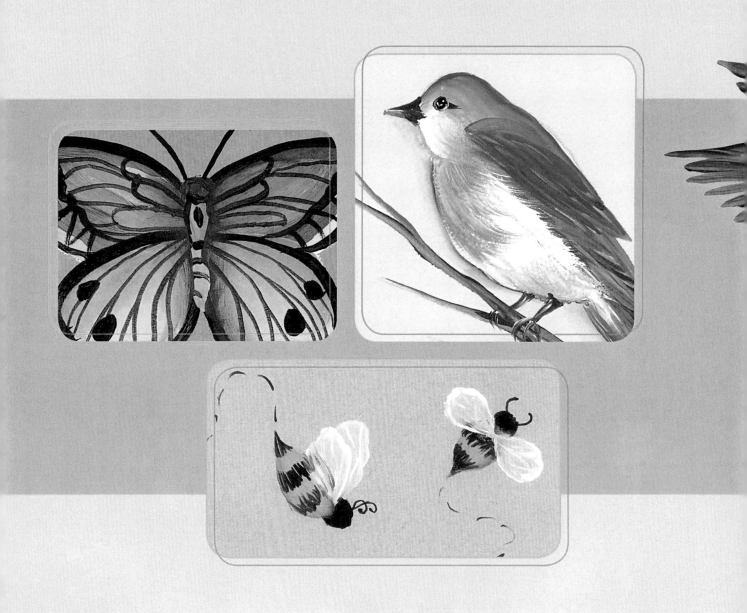

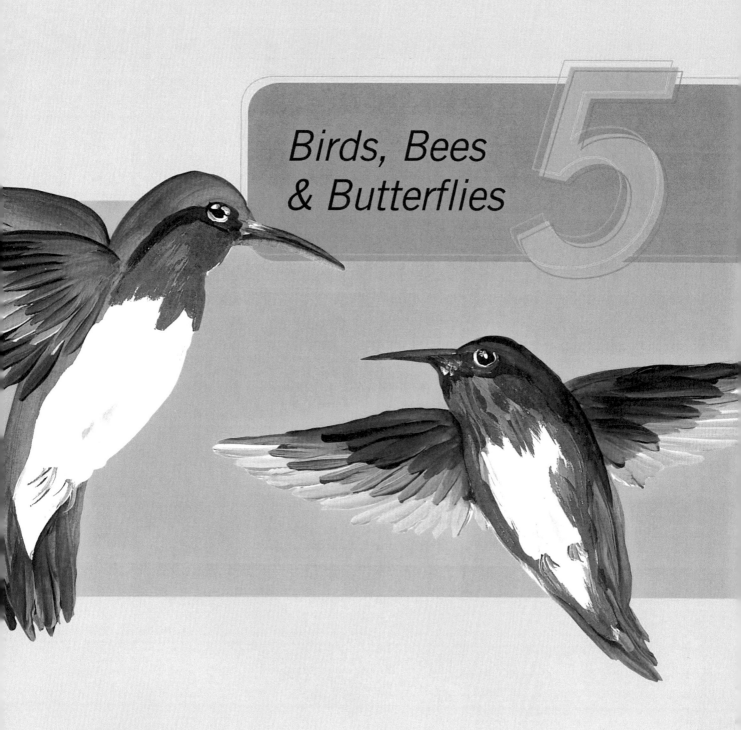

Birds, Bees & Butterflies

5

Hummingbirds

BRUSHES

no. 6 flat
no. 10 flat
no. 2 script liner

COLORS

Green Forest Yellow Citron Wicker White Engine Red Licorice

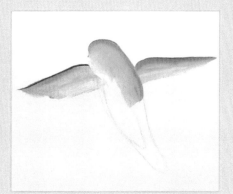

1. On a no. 10 flat, double load Green Forest and Yellow Citron and paint the placement of the upper part of the wings and the upper body and head shapes. The dark green side of the brush should define and shape the outer edges.

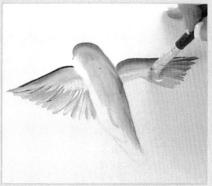

2. With the same brush and colors, begin stroking in each individual feather starting at the outer tip and pulling upward toward the upper part of the wing. Lead with the lighter side of the brush.

3. Turn your brush to lead with the darker green side and paint a shorter layer of feathers on the wings. These should overlap somewhat the feathers you just painted in step 2.

4. Pick up more Green Forest on the same brush and paint a third, shorter layer of wing feathers. The tail feathers are pulled from the outer tip upward toward the body.

5. Paint the bird's chest and belly with Wicker White, extending the white down over the tail feathers. Pick up Engine Red on a no. 6 flat and paint the red feathers around the white area on the throat, chest, belly and underside of the tail feathers.

6. The eye and beak are both painted with Licorice. The eye is shaped and highlighted with Wicker White, the beak is highlighted with Green Forest and Wicker White where it attaches to the head, and the feet are lined in with Licorice and Wicker White using the tip of the no. 2 script liner.

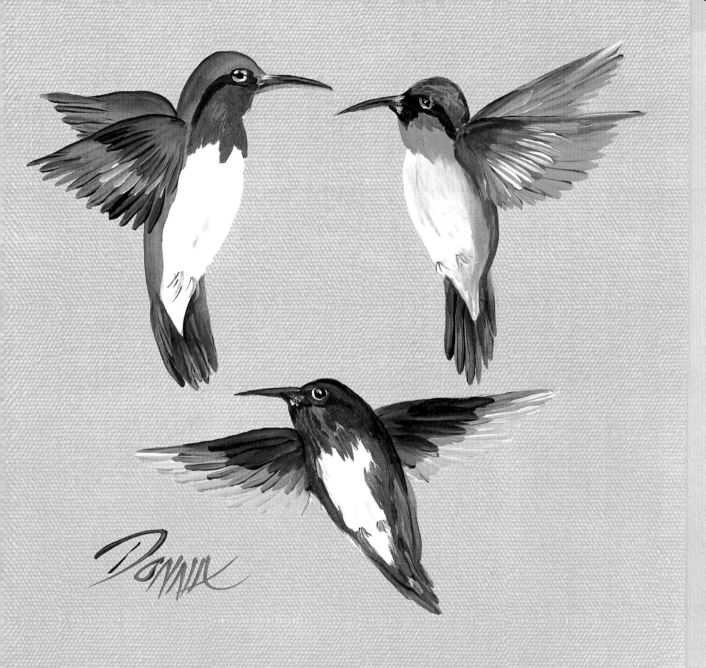

Robin

BRUSHES

no. 10 flat
1/2-inch (13mm) rake
no. 2 script liner

COLORS

Burnt Umber Burnt Sienna Wicker White Butter Pecan Pure Orange Licorice

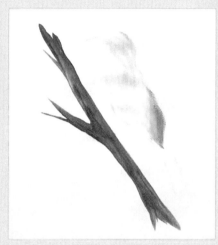

1. Double load Burnt Umber and Burnt Sienna on a no. 10 flat and paint the branch. With the dirty brush, pick up Wicker White and base in the robin's head and body.

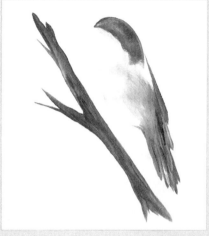

2. Shape the top of the head with Burnt Umber and Burnt Sienna. Using the dirty brush, pick up Butter Pecan and Wicker White and stroke each tail feather upward from tip to body. Soften and blend the area where the tail feathers meet the body using the 1/2-inch (13mm) rake brush.

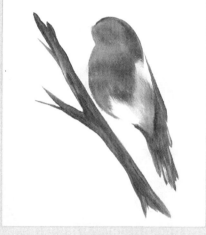

3. Load the 1/2-inch rake brush with Pure Orange and Butter Pecan and paint the brownish-orange breast and belly.

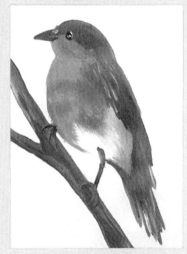

4. With Burnt Sienna and Burnt Umber on a no. 10 flat, begin the wing feathers. Pick up Butter Pecan to delineate the top layer of feathers. Pull the strokes from the tip upward. The eye is Licorice with a Wicker White highlight. The beak is Burnt Umber and Burnt Sienna. The legs and feet are Burnt Umber and Burnt Sienna.

5. To paint the open wing detail, double load a no. 10 flat with Burnt Umber and Burnt Sienna; pick up a little Butter Pecan. Paint the longest feathers with single strokes from the tip to the base. Pick up more Burnt Umber on the dirty brush and paint the next shorter layer of feathers, stroking from tip to base.

6. Finish the wing detail with more Butter Pecan on the dirty brush to paint the final, shortest layer of feathers.

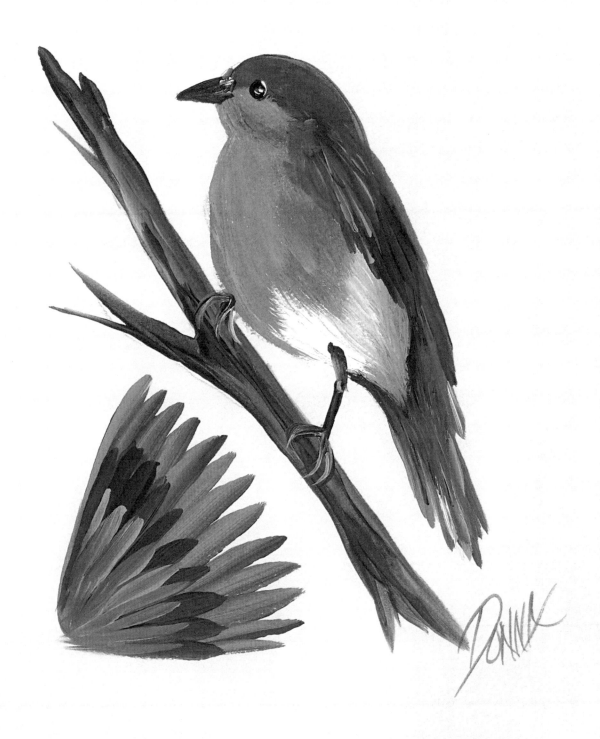

Bluebird

BRUSHES

no. 10 flat
1/2-inch (13mm) rake
no. 2 script liner

COLORS

Burnt Umber Wicker White Brilliant Ultramarine Pure Orange Burnt Sienna Licorice

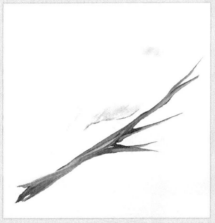

1. Paint the branch and twigs with Burnt Umber and Wicker White on a no. 10 flat. Basecoat the bird's belly with a thick coat of Wicker White. Pick up Burnt Umber on the same brush and shade underneath the belly from where the legs will extend. Pick up more Wicker White on the same brush and a tiny bit of Brilliant Ultramarine and add a light blue color to the belly, breast and throat.

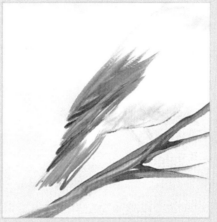

2. Begin painting the feathers with the tail and work upward. Double load a no. 10 flat with Brilliant Ultramarine and Wicker White. Pull strokes upward from the tip of the tail feathers to the body. Re-load your brush but this time pick up a small amount of Burnt Umber. Paint the ends of the wing feathers that are folded back over the tail feathers. Continue painting each wing feather, picking up a little Burnt Umber on your blue and white brush to delineate and separate the tips of the feathers.

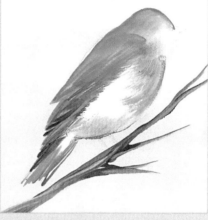

3. Darken the color of the blue wing feathers along the back. Use a 1/2-inch (13mm) rake brush and Wicker White to strengthen the white of the belly feathers where they meet the blue wings. Pick up Pure Orange, Burnt Sienna and Floating Medium on the same brush and add the brownish-orange tint to the upper breast and lower belly.

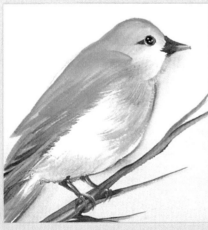

4. Paint the eye and beak with Burnt Umber and Burnt Sienna on a no. 2 script liner. Add a black pupil with Licorice, and outline and highlight the eye with Wicker White. The legs and feet are Burnt Umber and Wicker White.

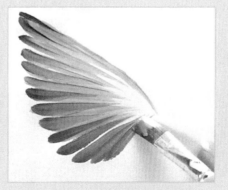

5. To paint the detail of open wing feathers, double load a no. 10 flat with Brilliant Ultramarine and Wicker White. Pull individual feathers starting at the top edge of the wing, the outer tips, and pulling toward the base. Pick up Burnt Umber on the brush when you reload with the blue and white to shade the outer tips and separate each feather.

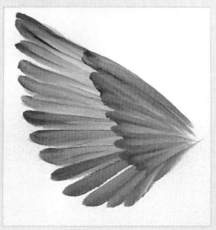

6. Paint a second, shorter layer of wing feathers overlapping the first layer, using more Burnt Umber to help separate the two layers.

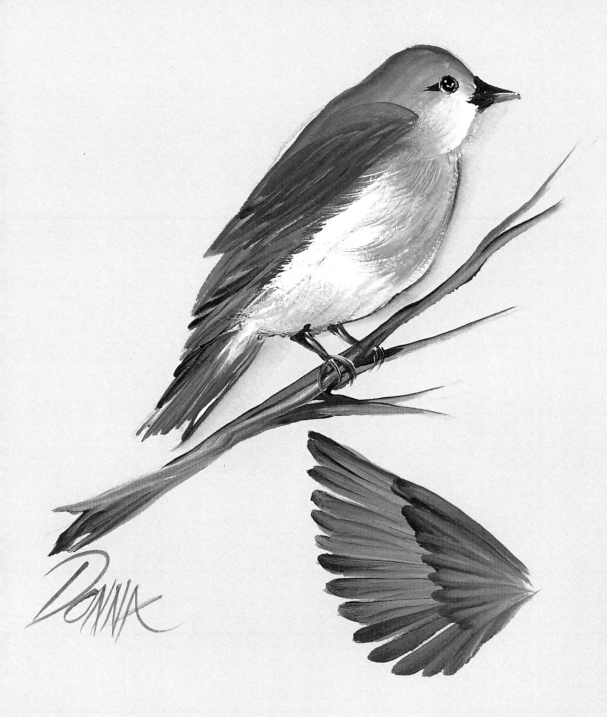

Butterflies

1. Basecoat the shapes of the wings with a no. 10 flat and Wicker White. The white basecoat helps the rest of the colors pop, especially if your background has any color to it. Do this for any of the three butterflies in this painting.

2. Apply color to the wings starting with Yellow Citron and Floating Medium. Shade the outside edges of the upper wings with Thicket. Using a clean no. 10 flat, pick up Floating Medium and Burnt Sienna and paint the bottoms of the lower two wings.

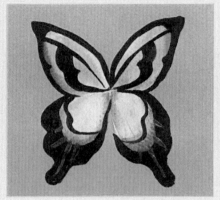

3. Load a no. 1 script liner with Licorice and outline the upper two green wings. Detail the lower two wings with the black but allow fine lines of Burnt Sienna to show through. Go back and reinforce these lines with Burnt Sienna if they don't show up enough. Detail the upper green wings with heavy black lines.

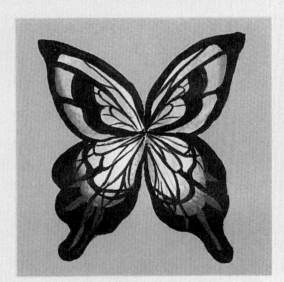

4. Switch to a no. 2 script liner and Licorice and paint very fine vein lines in the wings. The lines don't have to look exactly like these, but they do need to be very fine so use just the tip of the liner.

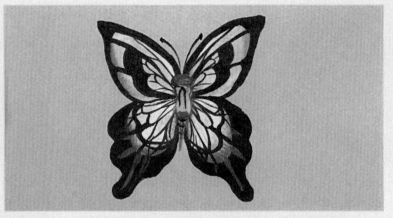

5. Basecoat the body with Yellow Citron. Paint the head and tail with Burnt Sienna, sideload float Burnt Sienna around the body to separate it from the wings. Detail the body and draw the two antennae with the no. 2 script liner and Licorice.

Pink butterfly: Basecoat with a no. 10 flat and Wicker White. Load a no. 12 flat with Floating Medium and Wicker White, sideload into Magenta, and paint the wings. Leave the white basecoat showing on the lower wings. With Cobalt Blue on a no. 6 flat, paint the blue detail lines. Pick up Wicker White on the blue brush and add light blue highlights and dots on the wings. Use inky Burnt Umber on a no. 2 script liner to outline the wings and add fine vein lines.

Yellow butterfly: Over the Wicker White basecoat, paint the wings with Yellow Light, Wicker White and Floating Medium on a no. 12 flat. Shade the upper wings with Engine Red; the lower wings with Burnt Sienna. The linework and details are all done with Licorice on a no. 1 and no. 2 script liner.

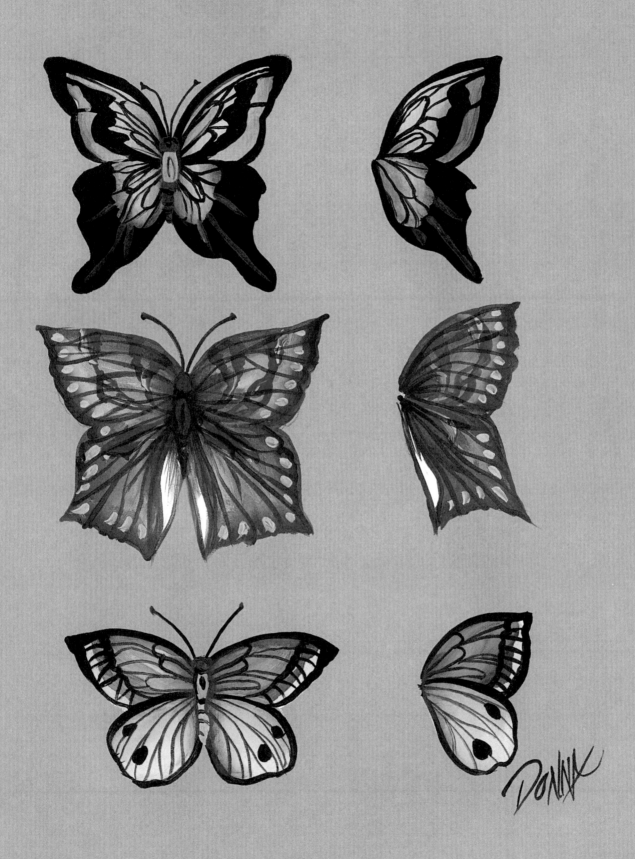

Dragonflies

BRUSHES

no. 8 flat
no. 12 flat
no. 2 script liner

COLORS

Wicker White Metallic Blue Metallic Burnt Umber
 Sapphire Emerald Green

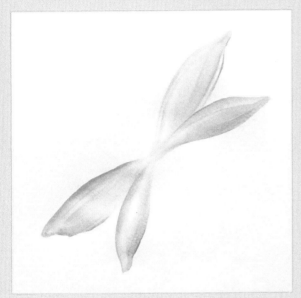

1. Load a no. 12 flat with Floating Medium and Wicker White. Sideload into Metallic Blue Sapphire. Paint the four wings, keeping the blue side of the brush to the outer edge of the wings.

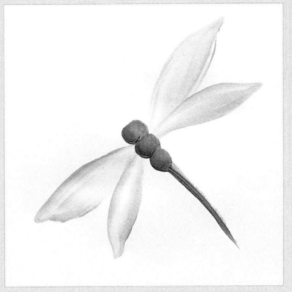

2. On a no. 8 flat, load Metallic Emerald Green and sideload into Burnt Umber. Paint the head, body segments and tail, keeping the brown to one side to shade and add roundness.

3. Load a no. 2 script liner with very inky Burnt Umber and paint very thin vein lines in the wings.

4. With the same brush and color, pull fine lines onto the base of the wings where they attach to the body. Then outline the bottom edge only of each wing. Paint different views of the dragonflies using the same brushes and colors.

Bees

BRUSHES

no. 6 flat
no. 8 flat
no. 10 flat
no. 2 script liner

COLORS

Yellow Ochre Yellow Light Licorice Wicker White Burnt Sienna

1. Double load a no. 10 flat with Yellow Ochre and Yellow Light. Paint the body shape. Use a no. 6 flat and Licorice to paint the head shape.

2. Paint the fuzzy black fur lines with Licorice on a no. 2 script liner. Keep the fine lines parallel but vary their lengths. Add the antennae and the trailing motion lines.

3. Load a no. 8 flat with Floating Medium and pick up Wicker White. Paint the two wing shapes. If your wings are too opaque, you need to pick up more Floating Medium to keep the white more transparent.

4. Shade the body with a sideload float of Burnt Sienna on a no. 8 flat. Load a no. 2 script liner with Wicker White and paint the veins in the wings. Finish the bee by adding little legs and feet with Licorice on a no. 2 script liner.

5. Here's another view of a bee from the top. Using all the same colors and brushes from Steps 1-4, first paint the body, the lines on the body, the head, antennae and trailing motion lines. Shade both sides of the body with a sideload float of Burnt Sienna.

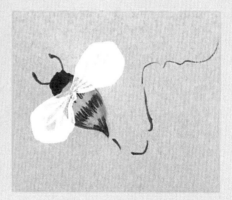

6. Paint the wings with Floating Medium and Wicker White and add the veins with straight Wicker White.

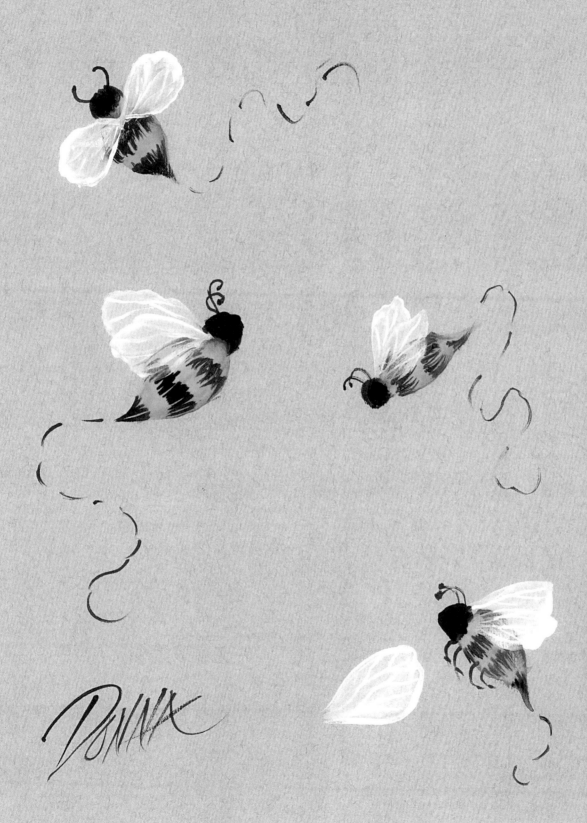

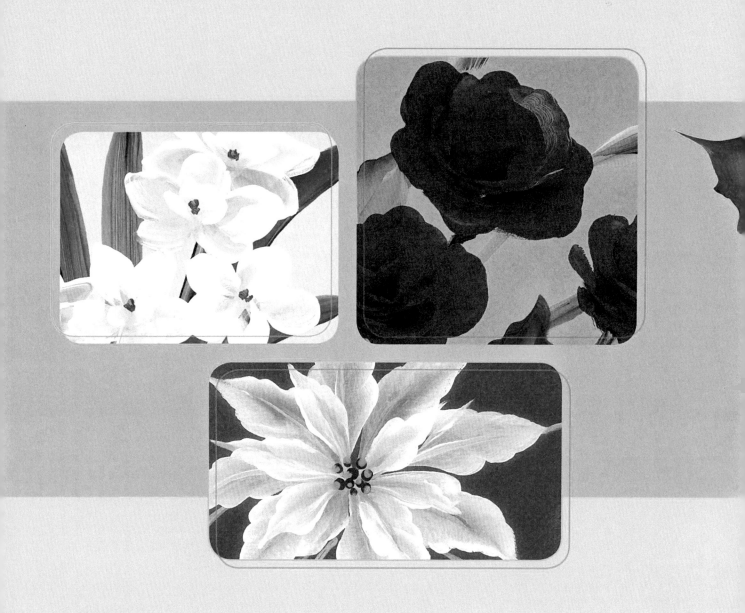

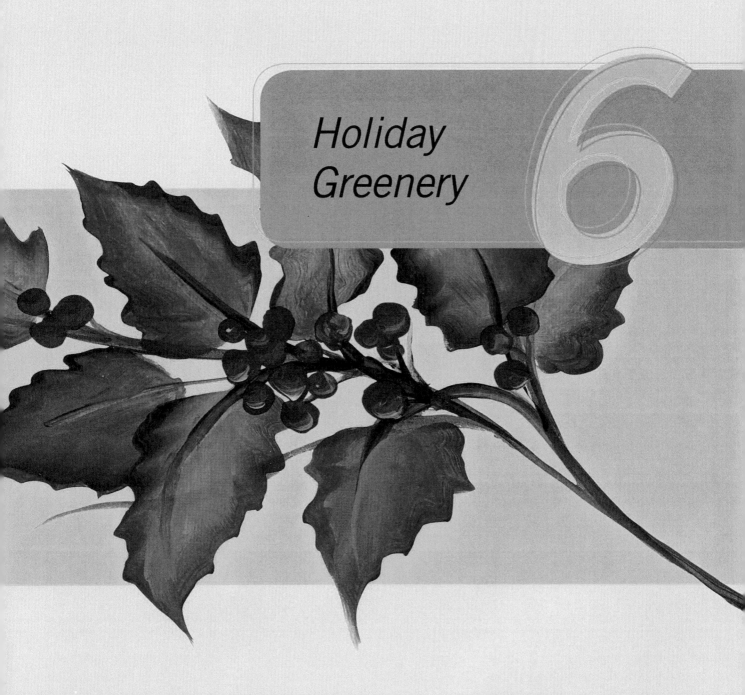

Holiday Greenery

6

White Tulips & Red Roses

BRUSHES
no. 12 flat
no. 16 flat

COLORS

 Green Forest

 Yellow Light

 Wicker White

 Yellow Citron

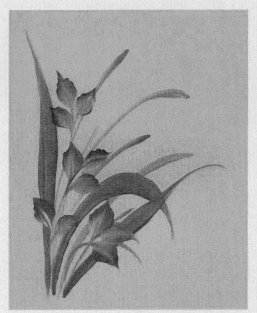 Engine Red

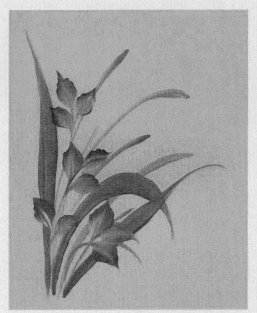

1. Place in the long slender tulip leaves and the smaller rose leaves with Green Forest and Yellow Light on a no. 12 flat. Pull stems for the tulips starting at the top and curving down to the base.

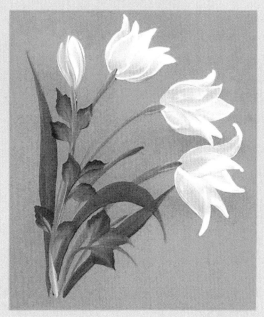

2. The tulip blossoms are placed at the tops of the stems with Wicker White and Yellow Citron on a no. 16 flat. Add a closed bud to the left and pull a stem.

3. Deepen the color on a couple of the open tulips with more Yellow Citron and Wicker White on a no. 12 flat. Brighten and define the petal edges with Wicker White.

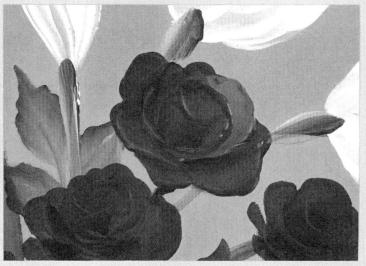

4. The red roses are painted with Engine Red on a no. 16 flat. Pick up some Green Forest on the brush for the shaded areas of the petals. Once the roses are placed in, pick up the same greens you used in step 1 and pull the stems, then fill in with more leaves wherever the design needs them.

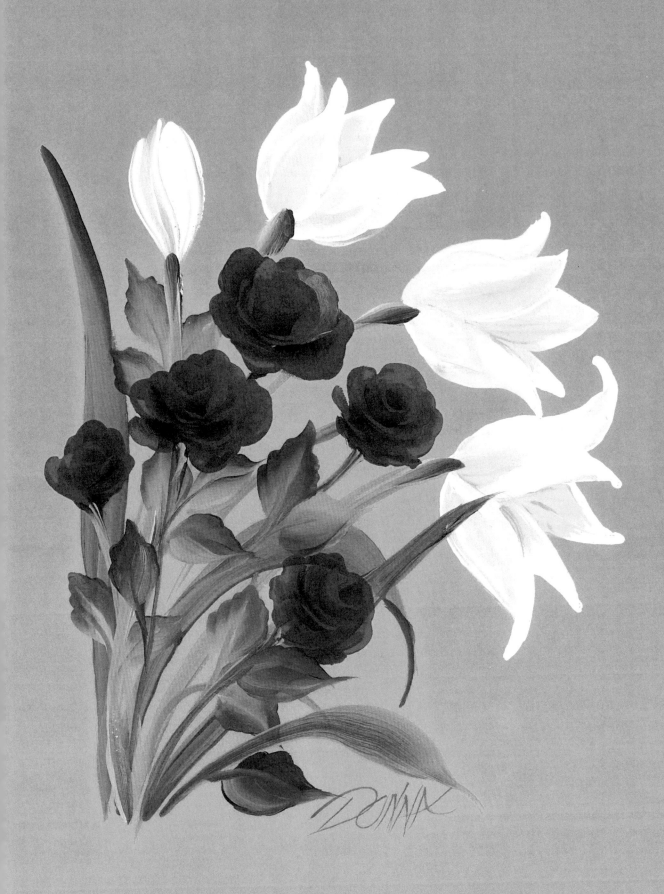

127

Paperwhite Narcissus

BRUSHES

no. 10 flat
no. 12 flat
no. 2 script liner

COLORS

Green Forest Yellow Citron Wicker White Alizarin
 Crimson

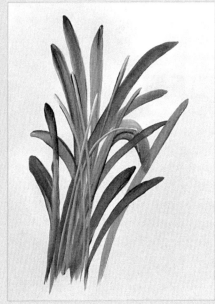

1. Double load Green Forest and Yellow Citron on a no. 12 flat, and pick up a little Wicker White sometimes for color variation. Paint the long slender leaves with curving strokes, starting at the tip and pulling toward the base. Add straighter, thinner lines for the stems, picking up more Wicker White.

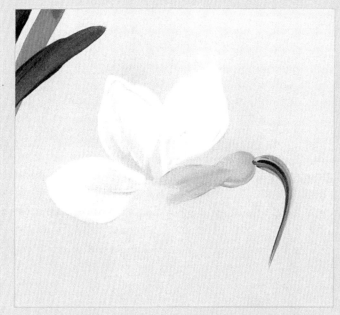

2. Begin the narcissus blossoms with a double load of Yellow Citron and Wicker White on a no. 12 flat. Paint the green base, then pick up Green Forest on the brush and pull a curving stem. Load a clean no. 12 flat with Wicker White and a little Yellow Citron and begin the skirt of petals, keeping the white side of the brush to the outside edges of the petals.

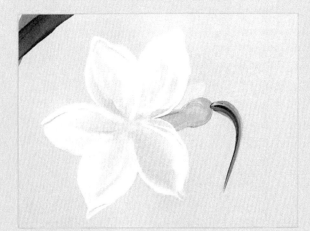

3. Add two more petals to the skirt for a total of five.

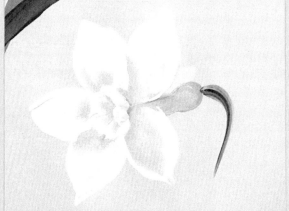

4. Switch to a smaller no. 10 flat and paint the center trumpet using the same Wicker White and Yellow Citron. Shade around the outer edge of the trumpet with more Yellow Citron to separate it from the back petals. Finish by dotting in the centers with Alizarin Crimson on the tip of a no. 2 script liner.

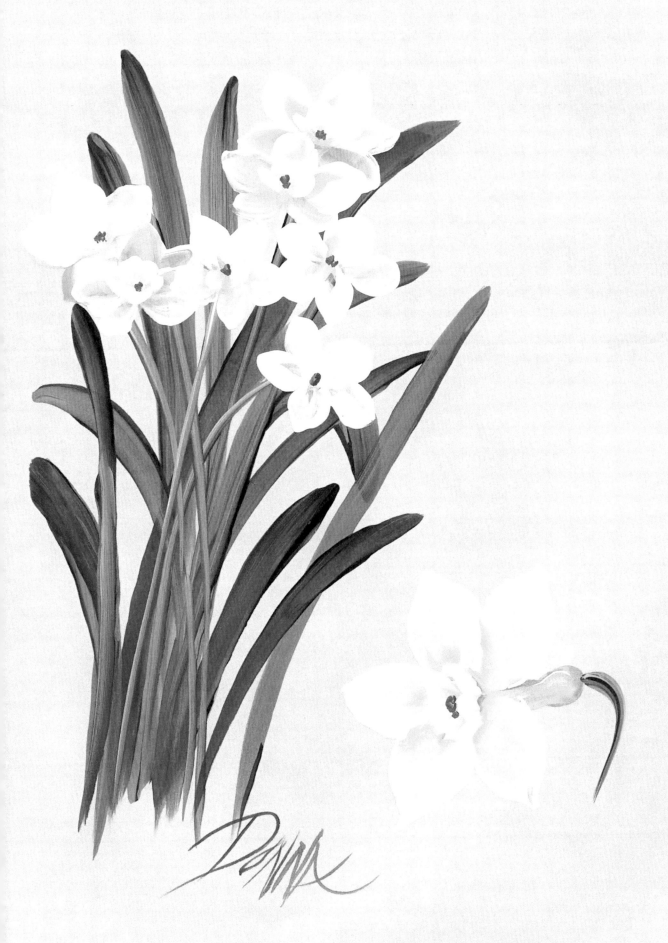

Amaryllis

BRUSHES

no. 2 flat, no. 8 flat, no. 12 flat, and a no. 2 script liner.

COLORS

| Thicket | Green Forest | Yellow Citron | Wicker White | Engine Red | Yellow Ochre | Burnt Sienna | Butter Pecan | Burnt Umber |

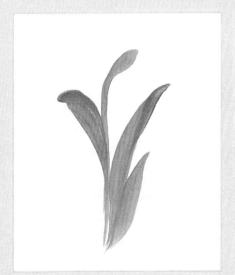

1. Double load a no. 12 flat with Thicket, Green Forest and Yellow Citron and paint the large leaves and the main stem. Amaryllis is a bulb flower so the stem is very thick and round.

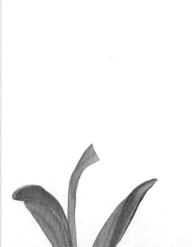

2. Load a clean no. 12 flat with pure Wicker White and place in the six petals. Each petal comes to a pointed tip. Slide your brush out to the tip, then back down to the base. Fill in the middle.

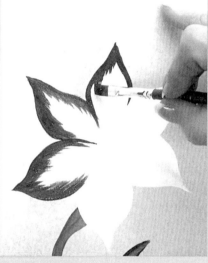

3. Load a no. 8 flat with Engine Red. Outline one half of the white petal with the red, then immediately pull fine lines straight downward while the red outline is still wet. Use the chisel edge with light pressure.

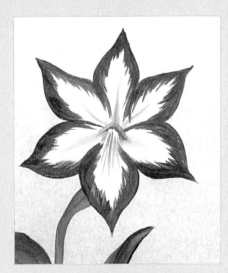

4. Load Yellow Citron on a no. 8 flat and paint the center throat, pulling lightly out into the center of each petal. Go over the curve of the throat with Thicket, and pull this color lightly onto the petals. Use a no. 2 script liner and Thicket to pull the fine stamens downward.

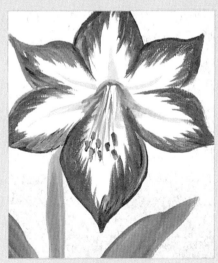

5. Tap on pollen with Yellow Ochre and Burnt Sienna on a no. 2 flat, using the chisel edge.

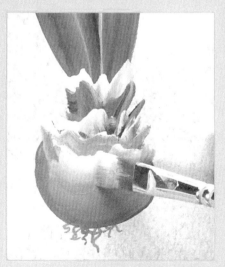

6. The bulb is painted with Butter Pecan, Burnt Umber and a touch of the greens used in step 1. Pick up Wicker White on one edge of the brush and work downward from the base of the leaves, add more layers as you go. The tiny roots are painted with inky Burnt Umber on a no. 2 script liner.

130

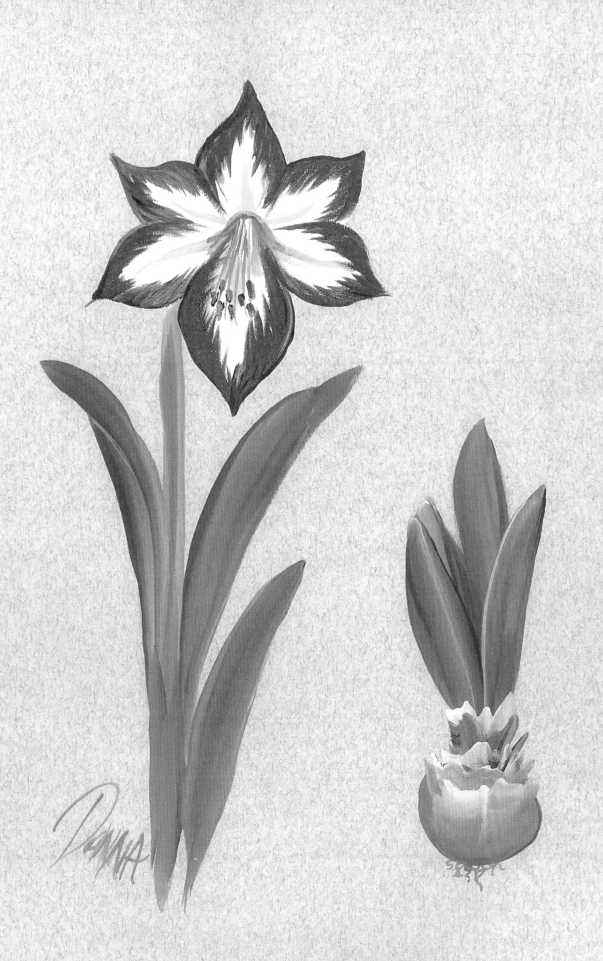

Holly & Berries

BRUSHES

no. 6 flat
no. 12 flat
no. 1 script liner

COLORS

 Burnt Umber

Green Forest

 Lemon Custard

 Engine Red

 True Burgundy

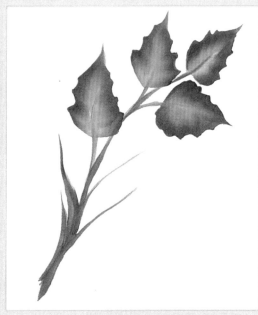

1. Place in the branch with Burnt Umber on the chisel edge of a no. 12 flat. Some of the smaller stems are painted with Green Forest. Double load Green Forest and Lemon Custard on a no. 12 flat and paint the holly leaves along the branch.

2. Each holly leaf is painted in two halves. Keep the Green Forest side of the brush to the outside edge and use a wavy motion of the brush to create the sharp points. Lift to the chisel and pull to the tip.

3. Turn the brush over to keep the Green Forest side to the outside edge and paint the other half. Use the chisel edge to pull a stem partway into the leaf.

4. The holly berries are based in with Engine Red sideloaded into True Burgundy on a no. 6 flat.

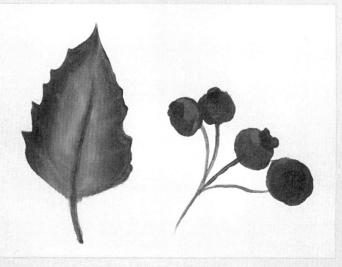

5. Load a no. 1 script liner with Burnt Umber and Green Forest and tap on the blossom end on each berry. Vary the placement. Pick up more Green Forest on the same liner brush and pull the little stemlets.

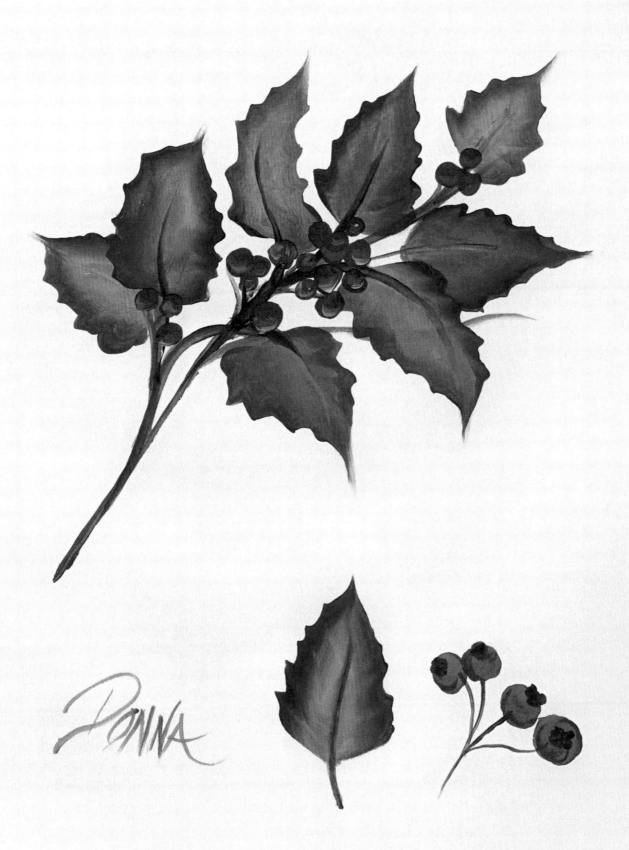

White Poinsettia

BRUSHES

no. 2 flat
no. 12 flat
no. 16 flat

COLORS

Wicker White

Metallic Inca Gold

Thicket

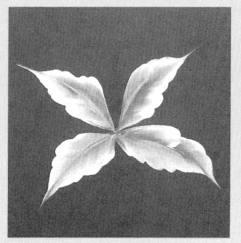

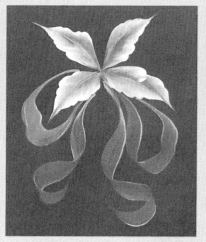

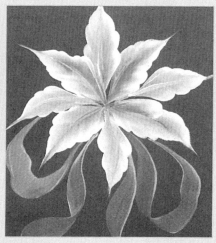

1. Double load Wicker White and Metallic Inca Gold on a no. 16 flat. Dip the chisel edge into Floating Medium and paint the four outer petals (or bracts) of the poinsettia. Keep the white side of the brush to the outside edges of the petals.

2. Load a no. 16 flat with mostly Metallic Inca Gold, a little Wicker White, and Floating Medium. Paint the organza ribbon starting with the two big loops. Give yourself plenty of room for the next two layers of poinsettia petals. Paint the hanging ribbon ends keeping the paint translucent.

3. Paint four more petals in-between the original four using the same brush and colors used in step 1. These petals are shorter and smaller than the first four. This completes the outer skirt of petals.

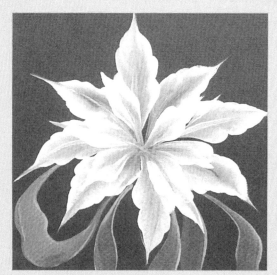

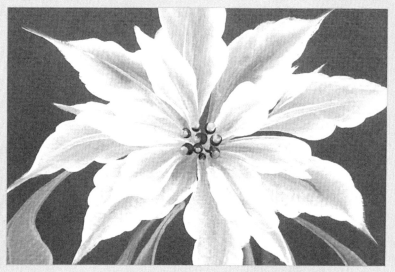

4. The next layer has five smaller, shorter petals. Use a no. 12 flat and paint these with more Wicker White in the brush so they are brighter white than the outer layer of petals. Pick up some Metallic Inca Gold on the chisel edge and pull a center vein out onto these petals.

5. The seedpods in the center are dotted on first with Thicket. Let that dry, then dot the Thicket with Metallic Inca Gold. Use the tip end of the handle of a no. 2 flat to get nice round dots.

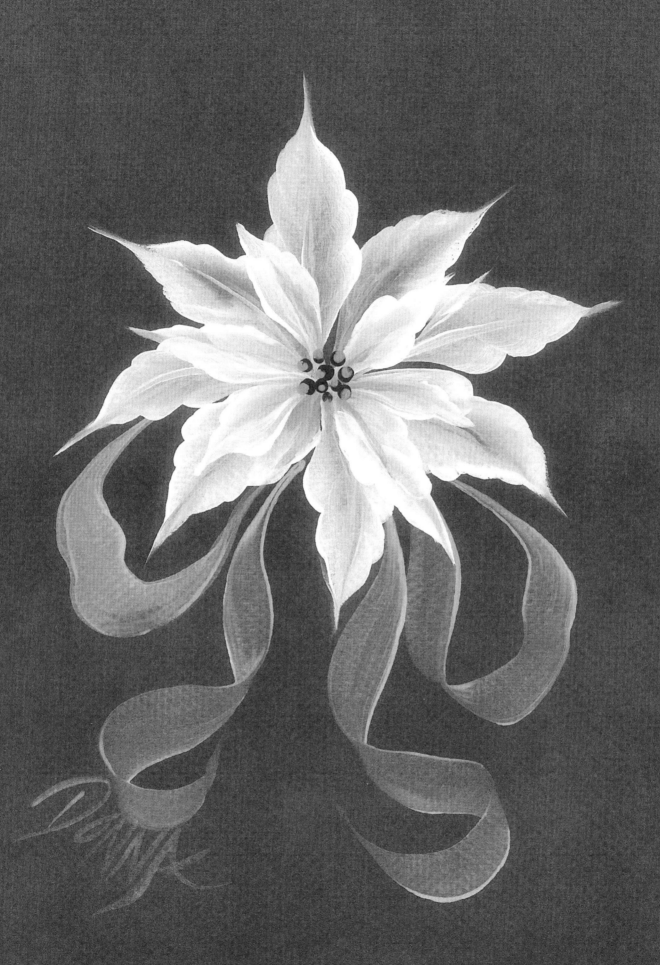

Compositions

7

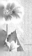

Mixed Floral Bouquet

no. 8 flat, no. 10 flat, 3/4-inch (19mm) flat, 1/4-inch (6mm) scruffy, and a no. 2 script liner.

COLORS

Thicket Green Forest Wicker White Magenta Yellow Light Lemon Custard Purple Lilac Night Sky Yellow Citron

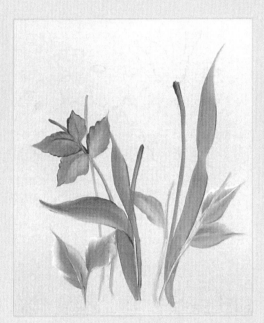

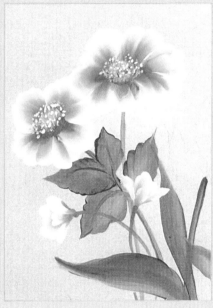

1. Place in the leaves and stems using a variety of colors since this is a mix of flowers. The main green is Thicket, with Green Forest sometimes for darker stems or leaves, and Wicker White sometimes for white edges.

2. The pink flowers are painted with a double load of Magenta and Wicker White. Keep the white to the outside edge of the petals. The centers are pounced on with the 1/4-inch (6mm) scruffy. Use Thicket for the lower, shaded part of the center, and Yellow Light for the upper, lighter color. For the fine stamens, pull inky Thicket upward, then dot on pollen with Wicker White on the tip of the script liner.

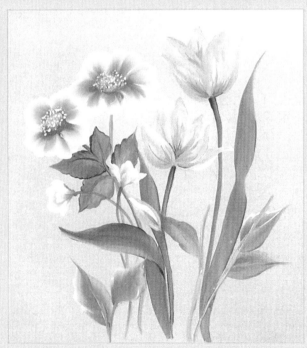

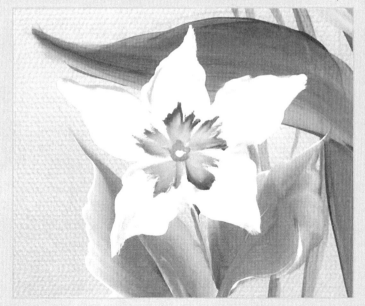

3. The tulips are painted with Lemon Custard and Wicker White for the yellow portion. For the pink shading, double load Magenta and Wicker White on a no. 8 flat and use the chisel edge and almost no pressure to pull the fine lines of pink color up from base.

4. The white clematis petals are based in with Wicker White on a no. 10 flat. To get the white ridge along the edges of the petals, just pick up a heavier load of Wicker White on one corner of the brush. The lavender centers are stroked on with Purple Lilac thinned with Floating Medium, then touched into Night Sky. Shade one side of each white petal with a sideload float of very thin Purple Lilac. Dot Yellow Citron in the center with the tip of the liner, then a smaller dot of Wicker White.

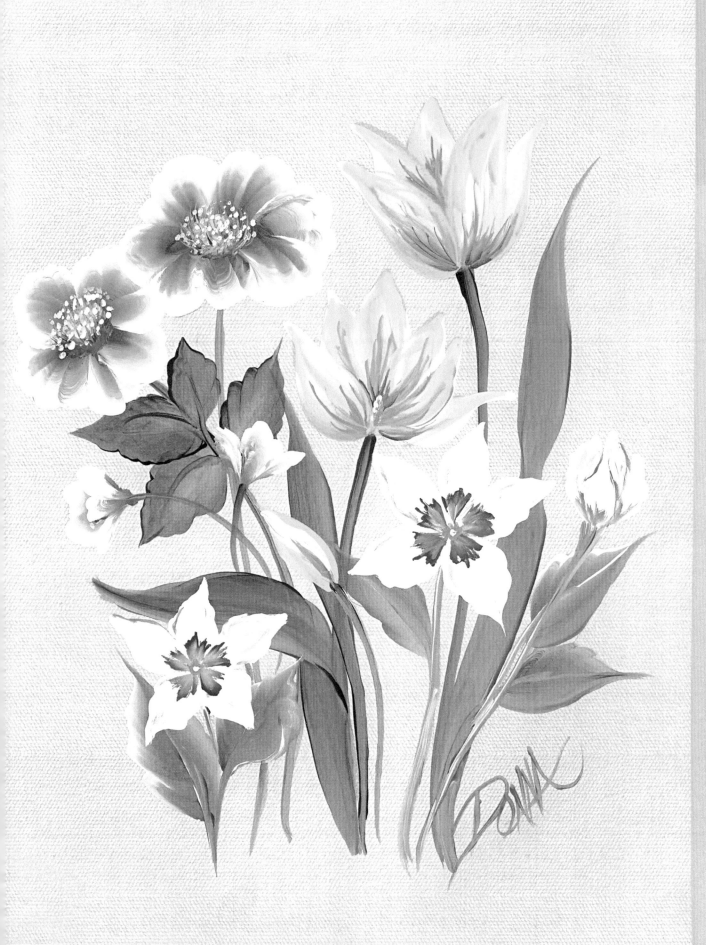

Asters & Autumn Leaves

BRUSHES

no. 10 flat, no. 12 flat,
no. 16 flat, and a no. 2 script liner.

COLORS

| Engine Red | True Burgundy | Pure Orange | Yellow Light | Yellow Citron | Night Sky | Purple Lilac | Wicker White | Thicket |

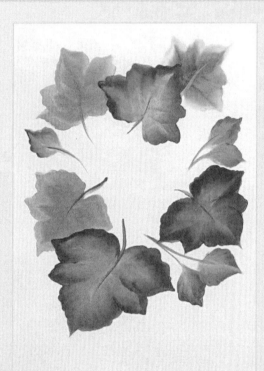 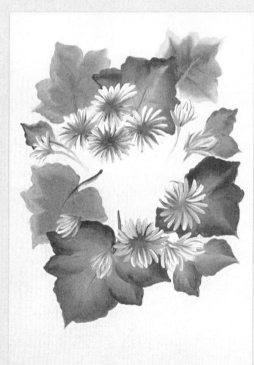

1. Paint a circle of autumn leaves using the following colors on a no. 16 or 12 flat: The darkest red leaf is a double load of Engine Red and True Burgundy. The orange leaf with the green edge is Pure Orange, Yellow Light and Yellow Citron. The other leaves are Yellow Light in the middle, with Engine Red and occasionally True Burgundy for the deeper reds along the edges.

2. The blue asters are painted with a no. 10 flat. Double load Wicker White and Night Sky sometimes, Purple Lilac other times, to get a nice variation of color in the petals. Darken the centers with straight Night Sky. Start the asters along the inside edges of the circle of autumn leaves.

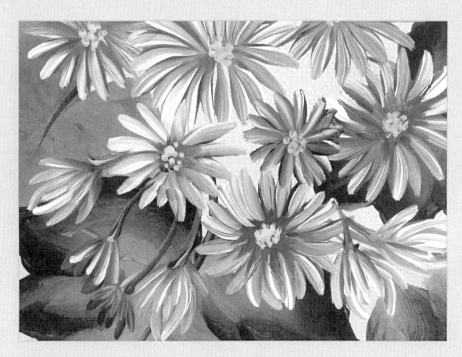

3. Fill in with more asters in the center. Make some of them sideview opening buds. Dot the centers of the open asters with Yellow Light on the tip of a no. 2 script liner. Pull stems into the opening buds with Thicket and Yellow Light on a no. 2 liner.

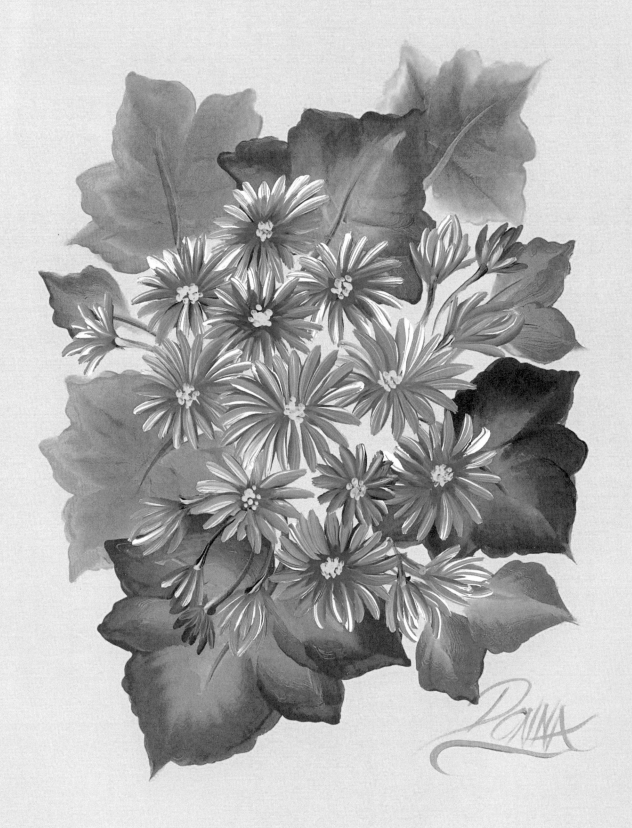

Wildflower Garden

BRUSHES

no. 6 flat
no. 10 flat
no. 12 flat
no. 2 script liner

COLORS

Thicket Yellow Citron Wicker White Brilliant Ultramarine Yellow Light Engine Red Licorice

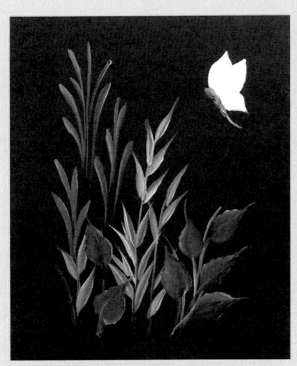

1. Paint the leaves first using a no. 10 flat for the smaller leaves and a no. 12 for the larger. The darker green leaves at the left and right are Thicket and Yellow Citron. The lighter leaves in the middle are Yellow Citron and Wicker White. Basecoat the wings of the butterfly with Wicker White on a clean no. 12 flat, then paint the body with Thicket and Yellow Citron.

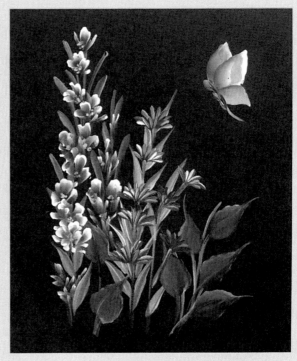

2. Add color to the butterfly with a double load of Brilliant Ultramarine and Wicker White, and use the same colors, plus a little Yellow Light for the centers, to paint the blue flowers on the left. The red flowers in the center are Engine Red and Yellow Light, plus a little Wicker White on the yellow side because Yellow Light is rather transparent. Color the edges of the butterfly's wings with Yellow Light and Wicker White.

3. The yellow poppies are painted with Yellow Light and Wicker White, and the centers are Licorice dotted on with the tip of a no. 2 script liner. To finish the composition, add the antennae to the butterfly with Thicket and Yellow Citron on a no. 2 script liner. Using a no. 6 flat, detail the wings with Brilliant Ultramarine along the edges and draw fine vein lines with Licorice.

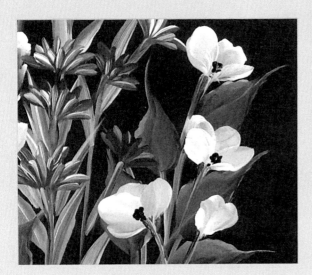

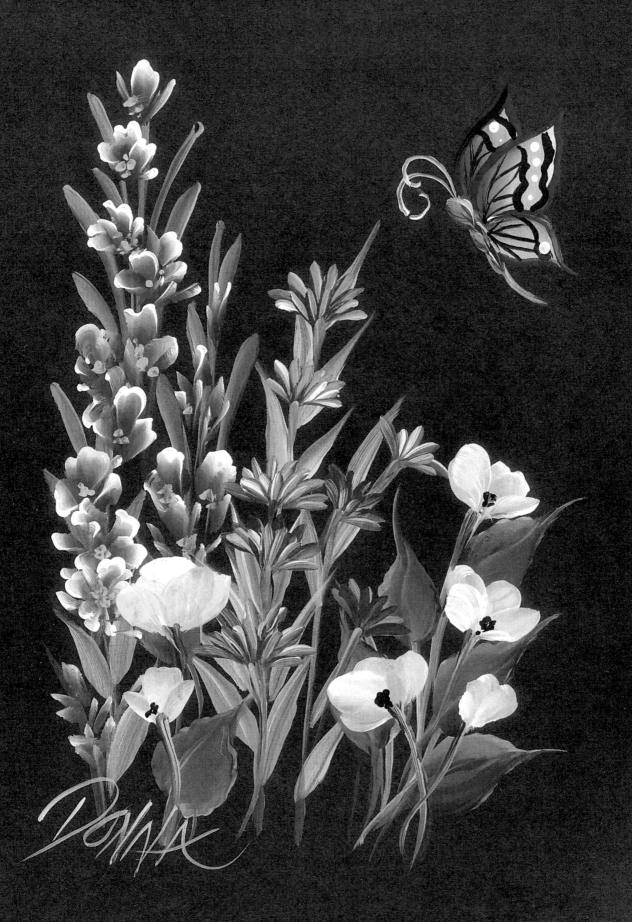

Fruit & Pine Holiday Wreath

BRUSHES

no. 8 flat, no. 12 flat, no. 16 flat, and a no. 2 script liner.

COLORS

| Yellow Citron | Wicker White | Thicket | Yellow Light | Yellow Ochre | True Burgundy | Night Sky | Violet Pansy | Engine Red | Burnt Umber |

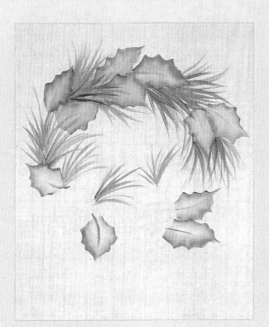

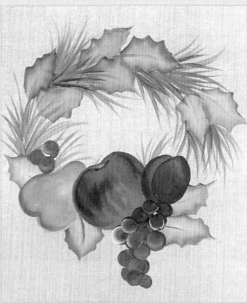

1. With Yellow Citron, Wicker White and Thicket, chisel-edge the pine needles using a no. 12 flat. Paint the holly leaves with a no. 16 flat. Leave space at the bottom of the wreath for the fruit.

2. The fruits are painted next with a no. 16 flat. The pear is painted with Yellow Light, Yellow Ochre and True Burgundy; the apple is True Burgundy and a little Yellow Light; and the plum is Night Sky and Violet Pansy. Switch to a no. 8 flat for the grapes, which are mostly Night Sky with highlights of Violet Pansy and Wicker White.

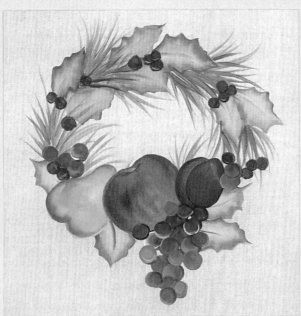

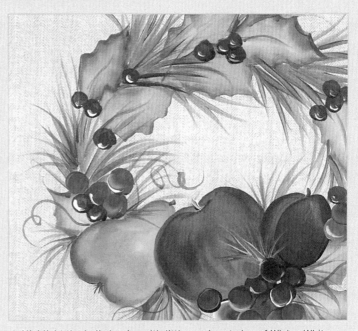

3. Fill in more grapes and highlight them, then begin the holly berries, using Engine Red and True Burgundy.

4. Highlight the holly berries with little curving strokes of Wicker White on a no. 2 script liner. Finish the composition with details such as the blossom end of the pear, the stem of the apple, and tendrils of inky Burnt Umber. Fill in among the fruit with more pine needles using a no. 2 script liner, and outline some of the holly leaves, all with the same greens you used in step 1.

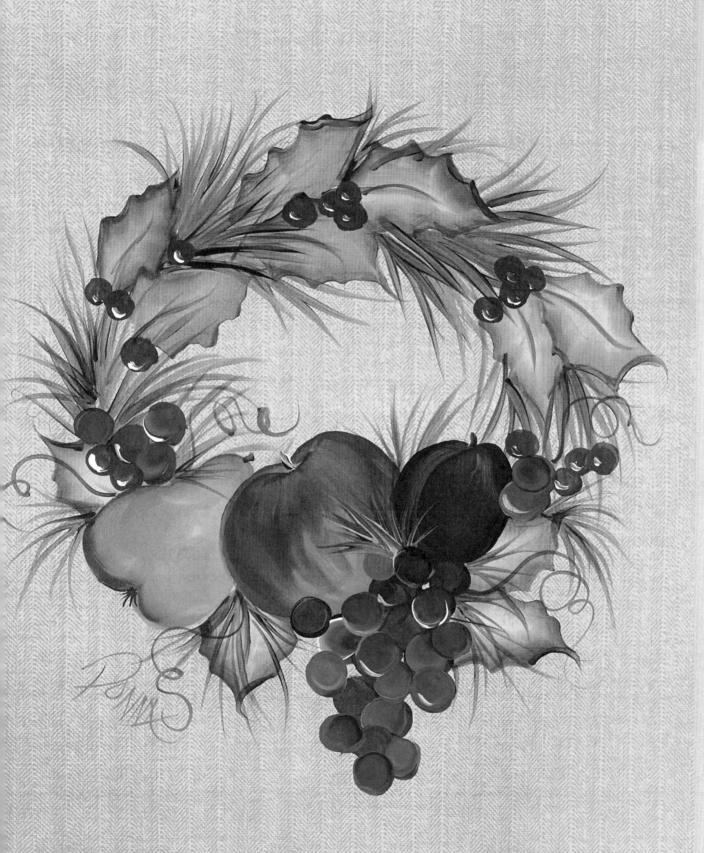

Hummingbird & Honeysuckle

BRUSHES

no. 2 flat
no. 8 flat
no. 12 flat
no. 2 script liner

COLORS

 Thicket

 Wicker White

 Yellow Citron

 Red Light

 Yellow Light

 Green Forest

 Aqua

 Licorice

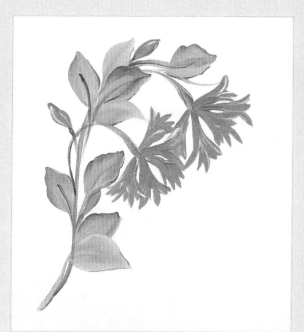

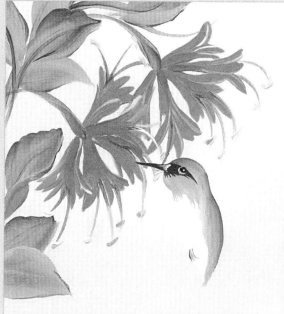

1. Place in the stems and leaves with Thicket and Wicker White plus a little Yellow Citron on a no. 12 flat. The main stem should curve up and over so the honeysuckle flowers can hang from it. Pull stems partway into the leaves. Using a no. 8 flat, load into Red Light then stroke through your puddle of Yellow Light. Paint the main honeysuckle flowers, then add a few unopened buds along the main stem.

2. With a no. 2 script liner, pull stamens of inky Green Forest and Yellow Citron, then add pollen dots. Base in the hummingbird with Thicket and Wicker White, picking up a touch of Green Forest if needed. Paint the blue throat feathers with Aqua. The beak and the eye are painted with Licorice on a no. 2 flat. The little feet are Licorice and Wicker White on the tip of the script liner.

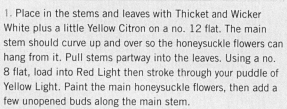
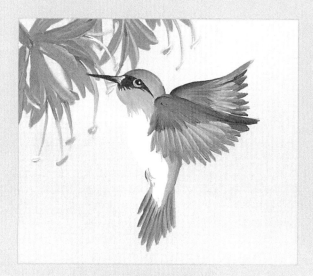

3. The bird's wings are stroked in with Thicket and Wicker White on a no. 8 flat. Stroke each feather separately. Add the tail feathers with upward strokes from the outer tip up to the body. Finish the composition by pulling a few more stems into the leaves and outlining the edges of some of the leaves using Thicket and the chisel edge of a no. 12 flat.

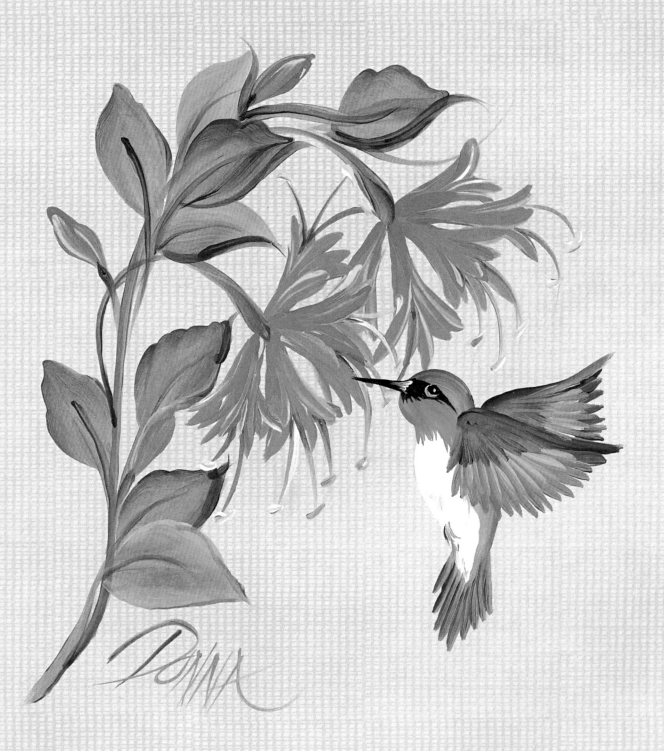

Berries & Vines

BRUSHES

no. 2 flat
no. 6 flat
no. 12 flat
no. 2 script liner

COLORS

Yellow Light Thicket Engine Red Night Sky Wicker White Yellow Citron

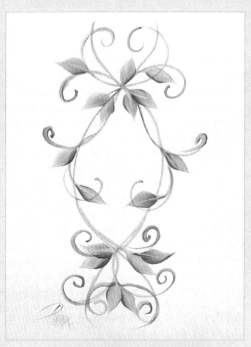

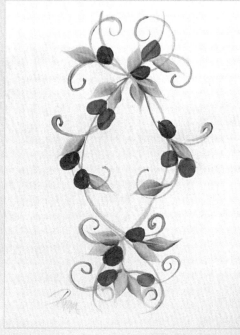

1. Use a no. 12 flat double loaded with Yellow Light and Thicket to paint the curving vines and the leaves. Add the curls with a no. 2 script liner and the same colors.

2. Basecoat the raspberries with Engine Red and the blackberries with Night Sky on a no. 12 flat.

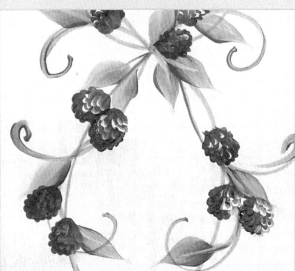

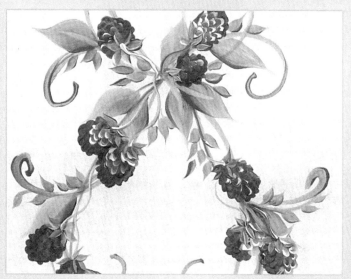

3. Paint the little individual seed segments with a double load of Engine Red and Night Sky on a no. 6 flat. Alternate picking up Wicker White sometimes on the Engine Red side so they show up better. Use one corner of the brush to stroke a little C-stroke or U-stroke to form each segment. The segments on the raspberries are painted with Engine Red double loaded with Night Sky for the outside segments and Wicker White for the inner ones.

4. The tiny leaves that form the caps on the berries are painted with Thicket, Wicker White and Yellow Citron on a no. 2 flat. The little stems where they attach to the vines are inky Thicket stroked through a little Wicker White on a no. 2 script liner. The small leaves along the curling lines and tucked in where the vines cross over are painted with Thicket and Wicker White on a no. 2 flat.

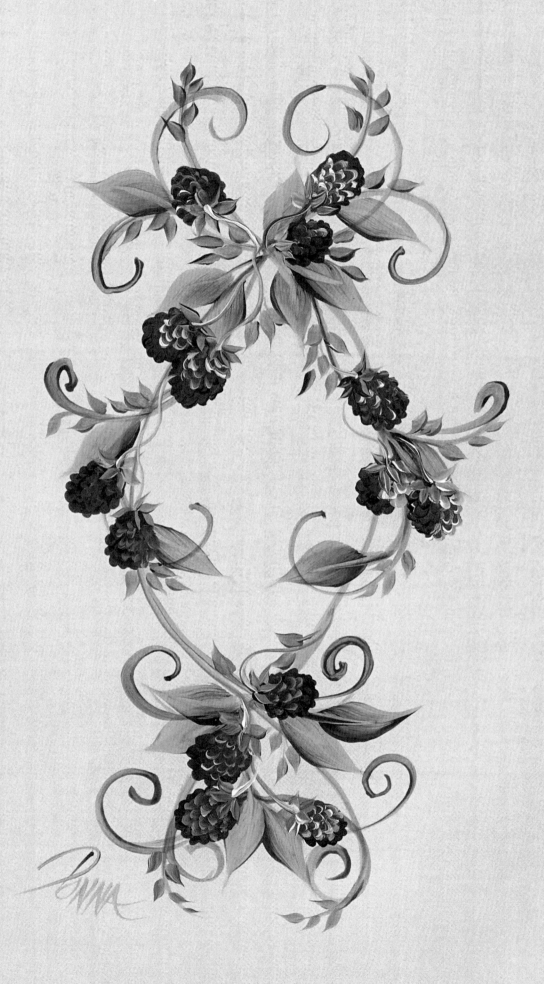

Tuscan Landscape

BRUSHES

no. 6 flat
no. 12 flat
3/4-inch (19mm) flat

COLORS

Thicket

Yellow Citron

Wicker White

Engine Red

Yellow Light

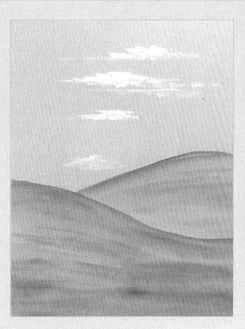

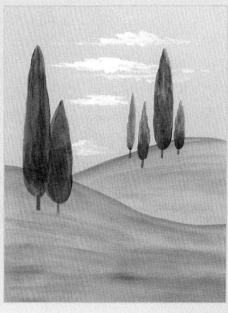

1. Choose a background color paper with a light greenish-grey tone for the sky. With a 3/4-inch (19mm) flat, wash in the back hill first with Thicket and Yellow Citron and Floating Medium. To wash in the front hill, keep the Thicket side to the top to define the edge and use gently curving strokes to fill in the hill shape. Add Wicker White cloud shapes by tapping the chisel edge of a clean no. 12 flat. Lightly pencil in the placement of the tall, thin cypress trees.

2. Paint the distant trees with Thicket, Wicker White, and Yellow Citron. Use vertical strokes to indicate the tall column-like shape and upward-growing branches. Paint the general shapes of the two foreground cypress trees.

3. Use a no. 12 flat double loaded with Thicket and Yellow Citron, occasionally picking up Wicker White, and detail the foreground trees with short vertical strokes, letting some of them extend over the edges to look like looser branches. Pick up Floating Medium on your dirty brush and paint shadows on the hillsides created by the trees, and tap on some foliage at the bases of the trees to ground them.

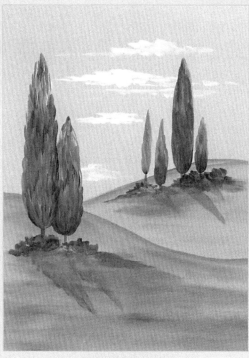

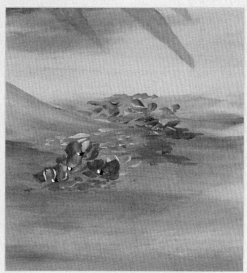

4. Thin some Engine Red with Floating Medium and wash a subtle tint of red over the valley areas to suggest distant fields of red poppies. Use a no. 6 flat and Engine Red and Yellow Light to add a few detailed poppies in the foreground. Dab the brush lightly to trail these poppy colors off into the background.

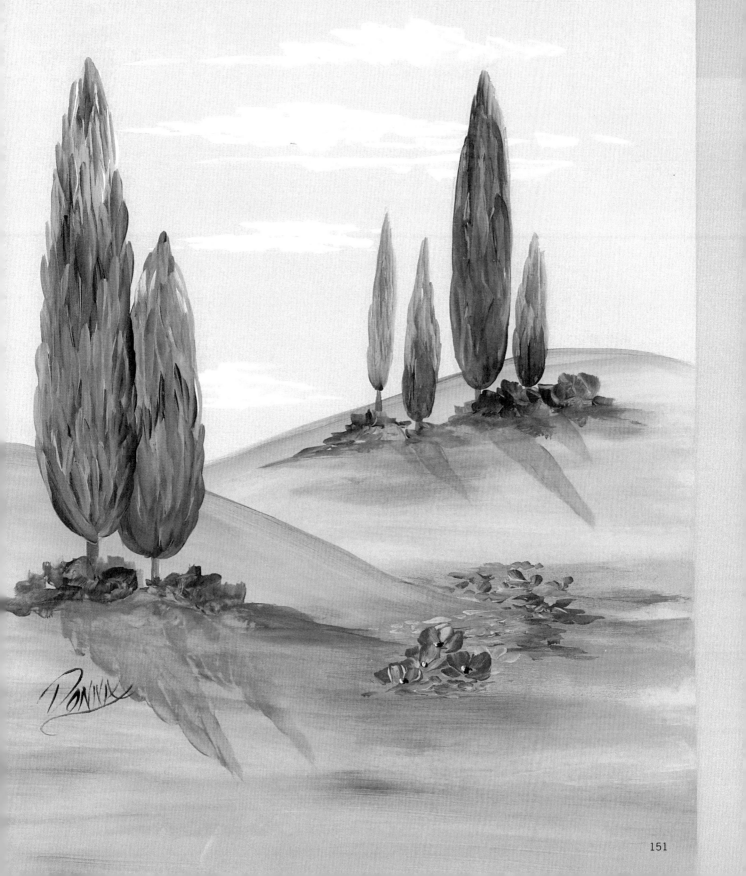

Orchids & Palms

BRUSHES

no. 16 flat
no. 2 script liner

COLORS

 Thicket

 Yellow Citron

 Yellow Light

 Wicker White

 School Bus Yellow

 Violet Pansy

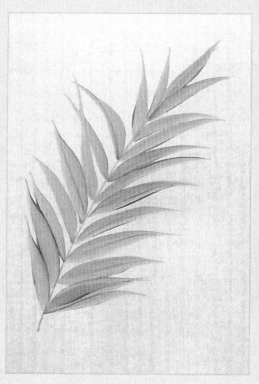

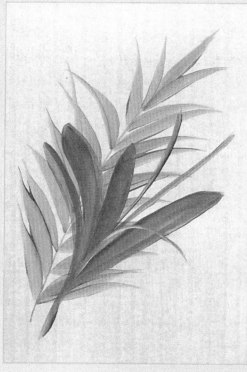

1. Place the palm frond in with Thicket and Yellow Citron on a no. 16 flat. Start with the stem, using the chisel edge of the brush. Then pull pairs of slider leaves, starting at the top and working down the stem. Pick up a little more Thicket on the brush for the darker leaves at the bottom.

2. Overlap the palm frond with the orchid leaves, using Thicket and a little Yellow Light on a no. 16 flat. Pull each leaf from the tip to the base. Chisel in a few stems for the orchid blossoms, picking up a little Wicker White on your brush.

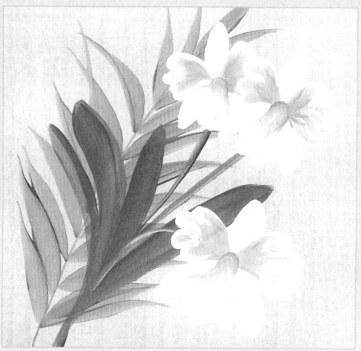

3. Begin the orchids with Wicker White for the outer petal shapes, using a clean no. 16 flat. Pick up Yellow Light on the same brush for the two ruffled side petals. Pick up a little Yellow Citron for the center petal. Reinforce the white petals with more Wicker White if they aren't bright enough or opaque enough. Shade the base of the center petal with straight Yellow Citron. Pull some fine streaks of School Bus Yellow outward from the base of the yellow side petals. Finish the composition by adding some fine speckles at the base of the all-white petals using inky Violet Pansy on a no. 2 script liner.

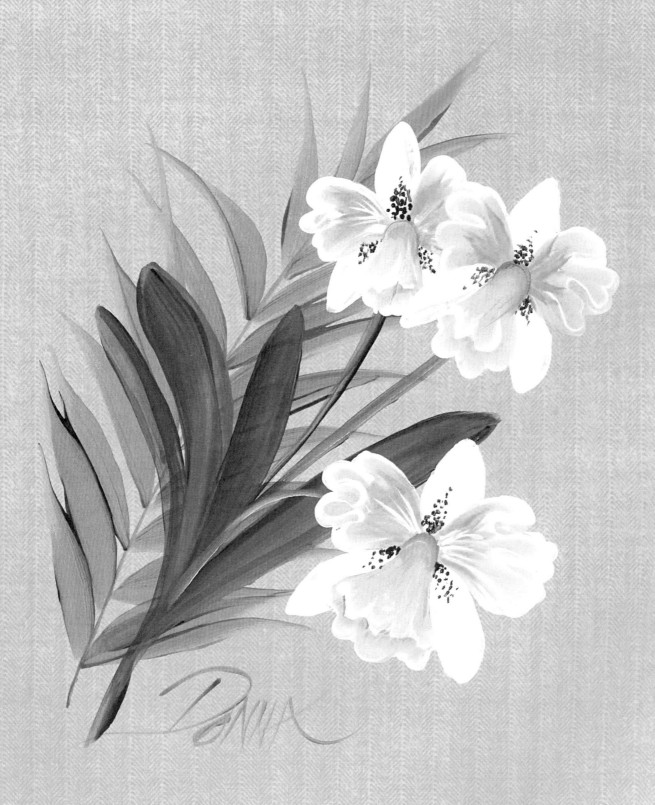

Design in Blue & White

BRUSHES

no. 8 flat
no. 12 flat
no. 1 script liner
no. 2 script liner

COLORS

Brilliant Ultramarine Wicker White

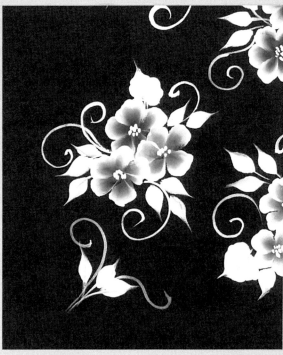

1. The blue and white flowers are painted with a double load of Brilliant Ultramarine and Wicker White on a no. 12 flat. Be sure to keep the Wicker White side of the brush to the outside edge of each flower.

2. Dot in the Wicker White centers with the tip of a no. 2 script liner. Paint the large ruffled-edge leaves, the three-leaf clusters and the curls all with Wicker White. Use a no. 8 flat for the leaves, and a no. 2 script liner for the curls.

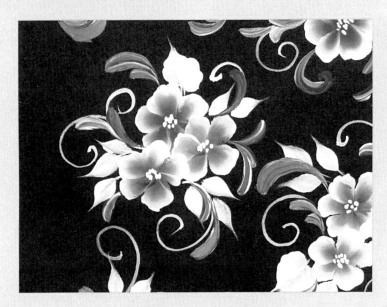

3. Add comma strokes and scrolls next using a no. 1 script liner loaded with Brilliant Ultramarine, then stroked through Wicker White on your palette. Alternate picking up these two colors to vary the shades of blue on the commas and scrolls. Finish the design with some smaller floral motifs in the upper right and lower left corners.

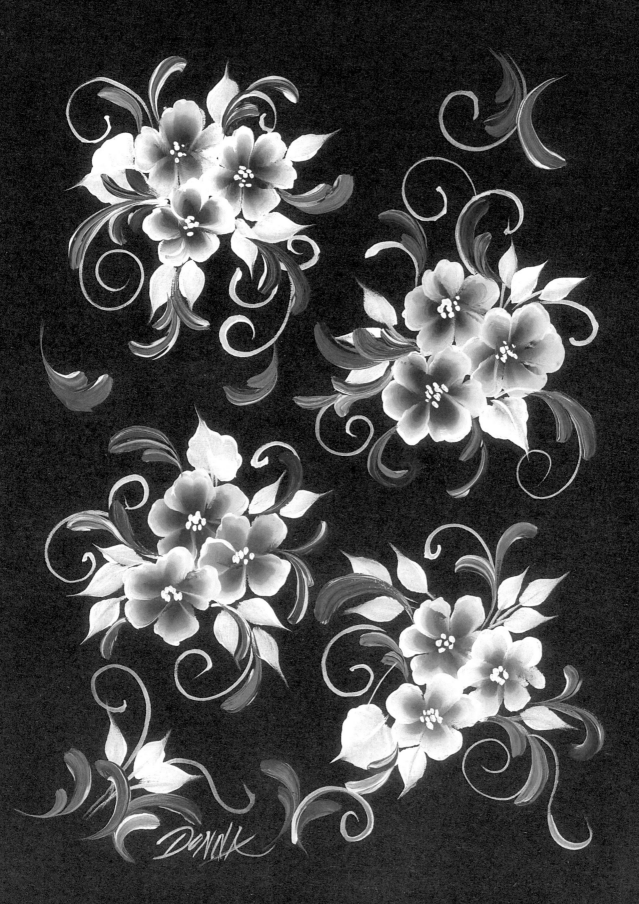

Summer Strawberries

BRUSHES

no. 8 flat
no. 12 flat
no. 16 flat
no. 2 script liner

COLORS

 Thicket Yellow Citron Engine Red Yellow Light True Burgundy Green Forest Burnt Umber Wicker White

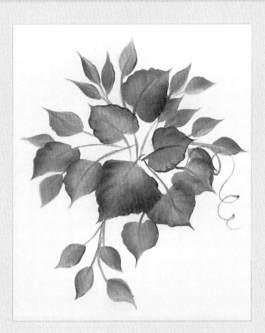

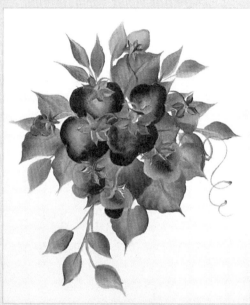

1. Double load Thicket and Yellow Citron, occasionally adding some Engine Red for color, on a no. 16 flat. Place all the stems and large leaves which are heart shaped, and smaller one-stroke leaves. The general shape of the cluster should be egg-shaped.

2. The strawberries are painted with Engine Red and Yellow Light. Highlight with Yellow Citron and shade with True Burgundy. The green hulls on the tops of the berries are the same greens as for the leaves, plus Wicker White occasionally for highlights and contrast.

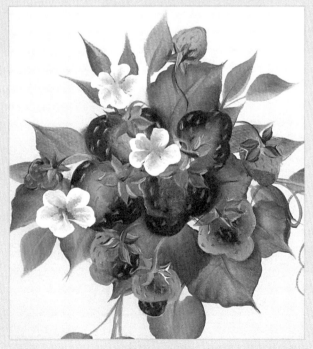

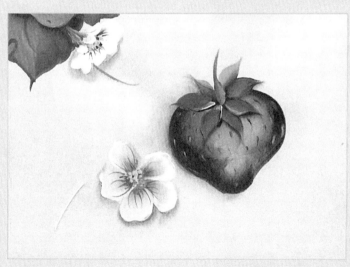

3. The seeds are lined on with a no. 2 script liner stroked through Yellow Light and Green Forest. Shade under and around the berries with a sideload float of Burnt Umber. The white flowers are Wicker White with a little bit of Burnt Umber on a no. 8 flat.

4. Detail the flowers with tiny lines of Burnt Umber radiating out from the centers. Tap on the centers with Yellow Citron and Green Forest. Sideload a no. 8 flat into Burnt Umber and float shading around and under the lower flower petals. This will bring the flowers forward, up off the background, and give more depth and dimension to the design. Finish the composition with curly tendrils of inky Green Forest on a no. 2 script liner. If you wish, add a bee to your composition—see page 122 for step-by-step instructions.

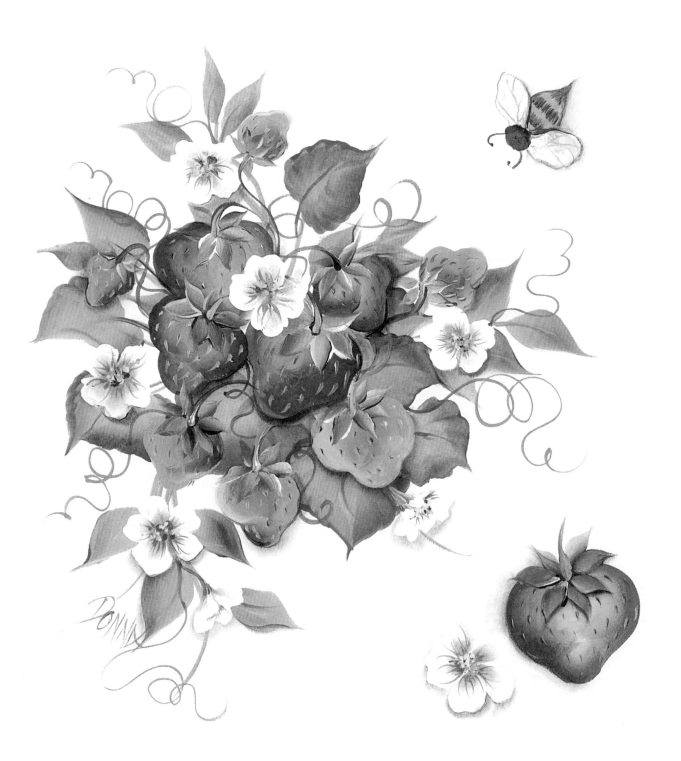

Resources

Index

U.S. RETAILERS

Paints, Brushes & Supplies

Plaid Enterprises, Inc.
3225 Westech Dr.
Norcross, GA 30092
Ph. (800) 842-4197
www.plaidonline.com

Dewberry Designs, Inc.
Ph. (352) 394-7344
www.onestroke.com

FolkArt paints, brushes and supplies are
also available at your local arts and crafts
supply store, such as Michaels, Hobby
Lobby, A.C. Moore Arts & Crafts, etc.,
and at many independent art materials
retailers.

CANADIAN RETAILERS

Crafts Canada
120 North Archibald St.
Thunder Bay, ON P7C 3X8
Tel: 888-482-5978
www.craftscanada.ca

Folk Art Enterprises
P.O. Box 1088
Ridgetown, ON, N0P 2C0
Tel: 800-265-9434

MacPherson Arts & Crafts
91 Queen St. E., P.O. Box 1810
St. Mary's, ON, N4X 1C2
Tel: 800-238-6663
www.macphersoncrafts.com

THE BEST IN DECORATIVE PAINTING INSTRUCTION IS FROM **NORTH LIGHT BOOKS!**

Fabric Painting with Donna Dewberry

Fabric painting is hot again! Follow along as popular One-Stroke painter and TV personality Donna Dewberry shows you step-by-step how to paint on fabrics of all kinds, from classic denim jeans and jackets to decorative silk pillows, cute baby gifts, casual handbags, kitchen aprons, and so much more. These are not your grandma's fabric paints—no puff-painted sweatshirts here! The new fabric paints are soft, flexible, and durable enough for years of machine washing. You'll find over 40 fresh and fabulous projects for your home and wardrobe, with hundreds of colorful step-by-step photos and clever tips from Donna. You'll love adding style and pizzazz to your painting life!
ISBN-13: 978-1-60061-073-8; ISBN-10: 1-60061-073-0; paperback, 128 pages, #Z1820.

Painter's Quick Reference: Birds & Butterflies

This easy-to-use reference book features a unique combination of quick, concise painting demonstrations and inspiring ideas from eleven of today's most popular bird and butterfly artists, including Sherry C. Nelson and Claudia Nice. You'll find 40 step-by-step painting demos that quickly show you how to paint a wide variety of birds, including cardinals, goldfinches, macaws, seagulls and peacocks, as well as gorgeous butterflies such as swallowtails, blue morphos, and yellow alfalfas. Bonus projects show how to paint details such as birds' nests, eggs and feathers, and comments and tips from the contributing artists give insight into the secrets of successful painting.
ISBN-13: 978-1-60061-031-8; ISBN-10: 1-60061-031-5; paperback, 128 pages, #Z1357.

Paint Charming Cottages & Villages

What landscape painting is complete without a lovely old farmhouse or a thatched-roof cottage? In ten complete step-by-step painting projects, you'll see how to create colorful cottages in a variety of architectural styles, such as Victorian gingerbread, English tudor, and Cape Cod, as well as old-fashioned village scenes just perfect for holiday greeting cards. Dozens of quick mini-demos show how to paint classic details such as porch swings, lace curtains, wrought-iron fences, decorative fountains and stained-glass church windows. Traceable patterns and color charts make it easy and fun!
ISBN-13: 978-1-60061-133-9; ISBN-10: 1-60061-133-8; paperback, 128 pages, #Z2277.

Fast & Fun Landscape Painting with Donna Dewberry

Learn to paint gorgeous landscapes the One-Stroke way! In this inspiring guide, beloved artist and PBS painting instructor Donna Dewberry shows how easy and fun it is to paint landscapes you'll be proud to display in your home. You'll find 15 start-to-finish painting demonstrations, 27 quick demos on how to paint the important details, and 15 handy tear-out cards featuring all of Donna's paint colors—no mixing or guesswork required. Most paintings can be completed in an afternoon or less, thanks to Donna's clever and easy painting techniques. What could be more fun?
ISBN-13: 978-1-60061-025-7; ISBN-10: 1-60061-025-0; paperback, 144 pages, #Z1309.

These books and other fine North Light titles are available at your local art or craft retailer, bookstore or online supplier, or visit our website at www.mycraftivity.com.

Made in the USA
Middletown, DE
17 June 2017